MODERN Mark Making

QUARRY

MODERN Mark Making

FROM CLASSIC CALLIGRAPHY TO HIP HAND-LETTERING

QUARRY BOOKS

Lisa Engelbrecht

First published in the United States of America by
Quarry Books, a member of
Quayside Publishing Group
100 Cummings Center
Suite 406-L
Beverly, Massachusetts 01915-6101
Telephone: (978) 282-9590
Fax: (978) 283-2742
www.quarrybooks.com

Library of Congress Cataloging-in-Publication Data

Engelbrecht, Lisa.
 Modern mark making : from classical calligraphy to hip hand-lettering / Lisa Engelbrecht.
 p. cm.
 ISBN 1-59253-419-8
 1. Lettering--Technique. I. Title.
 NK3600.E54 2008
 745.6'1--dc22

 2008002148

ISBN-13: 978-1-59253-419-7
ISBN-10: 1-59253-419-8

10 9 8 7 6 5 4 3 2 1

Design: Dawn DeVries Sokol
Cover Image: Lisa Engelbrecht and Dawn DeVries Sokol
Exemplars: Lisa Engelbrecht

Printed in China

This book is dedicated to all those people who believed that they couldn't do lettering, to all those unused calligraphy sets sitting untouched, and to all the calligraphers ready to take off the shackles and fly! Today is the day you begin—begin to letter without rules, begin use your tools with intention (and make new ones), and begin to believe (as I do) that you are incredibly talented and creative.

Contents

Page 38

Page 72

Page 80

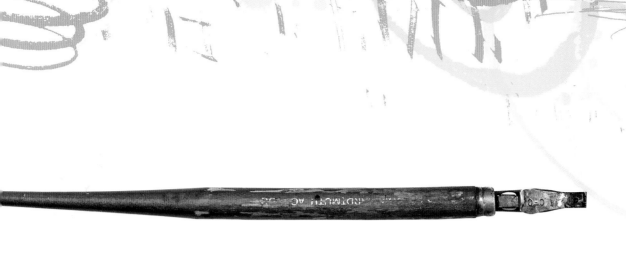

Page 94

Page 104

Page 140

Begin

I am a rebel. I admit it. I love lettering, calligraphy, and the beauty that well-written letters convey. But one thing I remember about my early years in calligraphy is that I always asked myself "What if I . . . ?(fill in the blank)." It's this spirit that has brought me to this moment.

To me, lettering represents an opportunity for uninterrupted inhibition, expressing oneself with spontaneity! It is a joyful, intuitive, physical act. I have been taking classes in calligraphy for years. I have laboriously copied and practiced letters. I continue to take classes with the masters of the letter arts, but I also continue to be a maverick, breaking the rules. (The calligraphy police haven't caught me yet!) I want to have fun with letters, take the mystique out of formal calligraphy, strip it down to simple directions, and encourage personal style. Is there a way to do this?

I am a lettering artist! I love telling people this. Most people get a quizzical look on their face. When I say I combine calligraphy, fabric, and collage in my artwork, they often seize upon the word calligraphy.

"Oh, calligraphy!" they say. "I tried that once, and it was too hard."

"I got a set at Christmas one year, tried it, and realized there was no way I could ever do it."

Or, "I don't know how you have the patience for that!"

Translation: It's too intimidating and difficult and requires hours of practice.

Is this your impression?

When I was given the opportunity to write my very own book on lettering, I knew that I needed to present an approach that was unlike any other presented in calligraphy instructional manuals. Yes, this is a book on lettering and

how to do it, but, more importantly, it is about mark making and being true to your own spontaneous and free expression. This is my attempt to show you the joy of letters, and the grace of making an expressive, wholly personal mark. This will be easy, because writing is an intuitive function, and we all possess this talent. (I want to remind you that you already have all you need inside you to make art. You need no previous experience!)

I love to make marks. We encounter personal marks made daily all around us, from the handwritten letter to graffiti we see on our way to work. Consider tattoos. Everyone, it seems, is trying to make a mark in this world. The traditional calligraphers believe a formal education in the historical structure of letters is essential. I, too, believe this can only help your calligraphy. You can compare it to learning the piano; it's tough to be an expressive pianist without a lot of practice. But what of the joy of the messy scribble, the play with the pen, the personal expression? Is it not as valid? I feel calligraphy is the fine barrier between art and the need for expression. But it is also mark making. Being true to your purpose and choosing meaningful text will show in your marks and help you access the essential core of this art.

In the following chapters, I present various styles of lettering, project ideas, and most importantly, samples of some of the most exciting lettering trends by some of today's best artists. This book will be a starting point for you to explore various tools and techniques to help you find your own personal lettering style. Trace or copy the exemplars. You don't need to follow this book from the beginning, look for a style you like. If you're like me, you'll start anywhere. Have fun, play, and make your own mark!

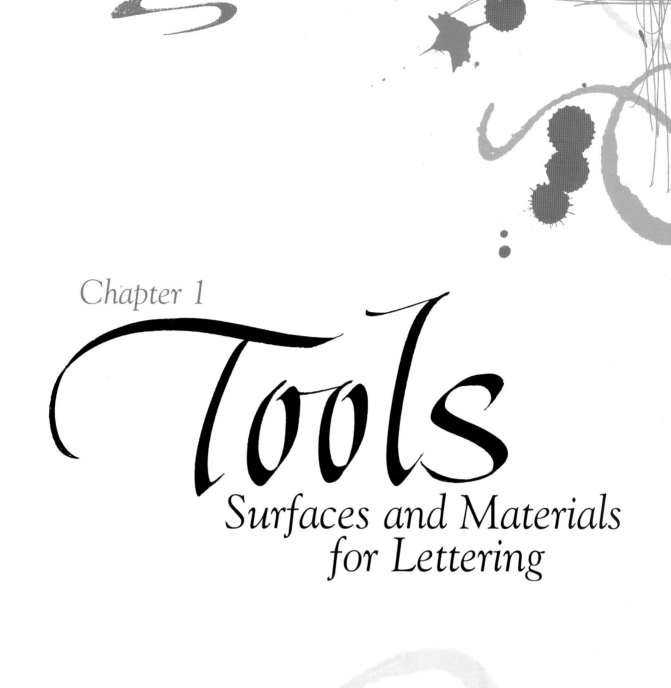

Chapter 1

Tools

Surfaces and Materials
for Lettering

To Write With

So just what is a pen nib anyway? Nibs, sometimes called pen points, are the metal inserts that hold the ink (sometimes with a reservoir) and write the letters. There are literally hundreds of kinds of pen nibs, each offering a different style of line. The nibs pictured are my favorites; they're also the ones that beginners in my classes find easiest to use. However, and I'll reiterate this many times in this book, this is merely what works for me. Once you begin writing, you might find your experience to be different. Each has a different feel and reacts differently to the user, so try many, to find the one that works for you. Following are descriptions of some nibs that you can choose from.

Tape Nib: for edged letters, such as italic; comes in millimeter sizes (shown: 4 mm). This is cheapest of this type and, for me, the best. (a)

Hiro Nib: this one comes in larger sizes; good for posters and large formats (b)

Vintage Pointed Nib (shown: Turner and Harrison 15 R): good for Copperplate and scripty letters. These were manufactured in the early 1900s for everyday writing. (c)

Speedball C Series (shown: size 0): Speedball is the most readily available nib in the United States. I like using the bigger sizes of this nib for edged pen letters, such as italic letters, which have a thick and thin component. (d)

Nikko G Nib: from Japan, a good beginner nib for script; used for manga comic drawing, but is excellent for script letters, such as Copperplate and Spencerian. (e)

Brause Nib: manufactured in Germany, a favorite of many letter artists. I like it especially for the smaller sizes. It also comes in millimeter sizes, ranging from .5 mm to 5 mm. (f)

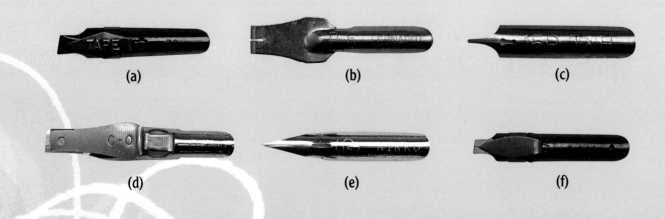

(a) (b) (c)

(d) (e) (f)

My Grungy Personal Collection

Sure, I could show you brand-new pen nibs with their holders, but these have much more character and history. Don't leave your pens in the rinse-water bucket, because the insides of the pen nib holders will rust, and the nibs will be impossible to extract (although you can use pliers in a pinch). Also, the paint will chip off. I use acrylic inks, which should be rinsed off immediately, because they can also ruin the nibs.

Wood marbled pen holder with a Brause nib
It was really pretty until I left it in water. Don't do this!

Automatic pen
These pens are great for large letters

Vintage nib in a plastic holder

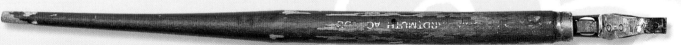

Speedball nib in a variation of a wood holder

Alternative Tools

Pilot Parallel Pen

A favorite of mine—especially for beginners. A cartridge pen, it comes in five sizes. The cartridges come in many colors, but the bonus is that you can fill this pen with any ink or gouache and even foiling size. It will not clog and comes apart easily for cleaning.

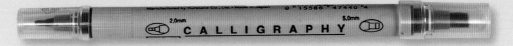

Zig Calligraphy Markers
A two-ended marker that is good for practice and available at most art stores. These are available in pigmented and waterproof inks, which makes them a good choice among markers.

Flat Brush
This can be used as a calligraphy tool when tilted to the correct angle. Comes in large sizes for posters and signs.

More alternative tools are discussed in Chapter 9, page 108.

Inks, Gouache, and More

It is harder to recommend inks and media (stuff to write with). My preferences may not be yours. Try a lot of different types, to see what works for you. Almost everything shown in this book has worked for me—use these recommendations as a jumping off point for experimentation.

There are basically two types of media: liquid and color that needs mixing.

Liquid Media

Sumi Ink: lovely, and sometimes scented with incense! An instant, intense black ink. I use this for all my black and reproduction work. Several brands are available (Moon Palace and Best Bottle are good). My favorite is Yasutomo. (a)

Higgins Eternal: the standard for beginning lettering. (b)

FW Acrylic Ink: great for fabric, very permanent. Be sure to wash your pens and brushes well, after using this media. Take an old toothbrush and clean beneath the reservoir of your pen. (c)

Speedball Super Pigmented Acrylic Ink: nice and liquid for the pen. (d)

Pearlescent Liquid Acrylic Ink, by Daler-Rowney: the best gold and shiny inks for fabric. When using this ink, pour it into a plastic palette well or a small cup, so that you can see how far in you are dipping the pen. (e)

Nonliquid Media

Designers' Gouache

This is creamy paint in a tube. Winsor & Newton is the premium brand; however, there are many other suitable choices. Look for the permanency rating on the back of the tube, and work only with the most permanent, or lightfast (meaning it won't fade in the light), color. Gouache is opaque (not transparent) watercolor and can be blended for rainbow writing and writing on black or dark paper. Tube watercolor can also be used, but it is not opaque. (f)

Walnut Ink

Walnut ink is made from peat moss, not walnuts. Buy the crystals, so you can mix it to your desired darkness. It produces a lovely, sepia brown color and is water-based but lightfast.

To dilute tube colors and walnut ink crystals, squeeze a bit of gouache into a palette well, or spoon out a tiny bit of crystals and dilute with warm water. Mix well with a stiff brush, until blended. Look for the consistency of old milk. Swipe the brush across the side of the pen nib to fill the reservoir halfway. If you place your palette in a plastic, zip-top bag, the mixed colors will last about one week. Once you have finished using your pen, be sure to clean it out with a toothbrush, especially if you're using acrylic ink. (g)

To Write On

When you see all the paper choices available at the art store, your head will spin. Here are a few of my favorites.

(a)

(b)

Paper to Practice On

Graph Paper Pad: 4 squares to the inch or a 5-millimeter quadrille pad. (a)

Design Vellum: you can see through this, so put a sheet of graph paper under it. (b)

Paper for Final Artwork

Canson Mi-Tientes: these come in a lovely range of colors; be sure to write on the smoother side. (c)

Arches Hot Press Watercolor Paper: comes in different weights, or thicknesses; 90-pound is great to begin with.

"Hot press" refers to the finish—it's much smoother than cold-press and easier to write on. (d)

Bristol Paper Pad: this paper has a smooth finish, and it's easily available. (e)

Other Papers I Like

Rives BFK Printmaking Paper: a smooth, creamy white paper.

Frankfurt Printmaking Paper: beautiful textured paper with wavy laid marks.

Ingres: a text-weight paper, great for book pages.

To cut your paper to size, measure and mark the paper with a pencil and cut along the line with your ruler and a new X-Acto blade, keeping the ruler on the paper you want to save. If you veer out, you will only wreck the scrap side of your paper. Make several strokes if necessary.

(d)

(e)

(c)

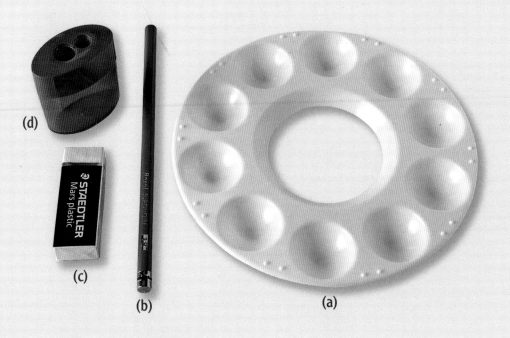

(d)

(c)

(b)

(a)

Other Supplies

Plastic palette for decanting ink, and for mixing gouache and walnut ink. (a)

A 2H, 3H, or 4H pencil for lining; these have harder leads and make thinner lines. (b)

Eraser for erasing those lines! (c)

Pencil sharpener to keep your pencils sharp for lining. (d)

18" (45 cm) metal ruler

X-acto knife for cutting paper with the ruler (please don't use scissors!)

Toothbrush for cleaning your pen nibs at the end of your practice (not shown)

Box for your stuff (not shown)

Water container for dipping in occasionally (not shown)

A Word about the Exemplars

Exemplars are the stylized alphabets that you'll find in most of the following chapters. Please feel free to use the exemplars to practice copying the letters. You can also use them to trace the letters, although I recommend limiting the amount of tracing you do; you'll learn the letters faster if you copy them. Use your graph paper to practice them.

Some exemplars have guidelines. These are the lines that delineate the proper height and proportion of the letters. I'll explain how to draw and measure these lines in the following chapter. A few of the exemplars show stroke sequencing and directions, for example, showing which parts of the letters are drawn first and in which direction the strokes originate and move. Follow them as closely as possible, unless you find an easier way to create a letter, in which case, you have my permission to go for it! Some exemplars do not have guidelines, because those letter styles do not need them. Experiment with the height of your letters, to get the stroke thicknesses that you prefer.

Modern Mark Making

Chapter 2

The

Basics

Techniques and
Getting Started

> **A good traveler has no fixed plans and is not intent on arriving.**
>
> —*Lao Tzu*

Lettering Spaces

Because you are taking the time to experiment and learn something new, you deserve a place to yourself to practice your art and lettering. While this space could be an elaborate extra room with skylights and drafting tables, most of us will have to settle for a small table in a cozy corner near a window.

Whether or not you have the finest materials and tools matters less than applying yourself to the learning. You might be one of those lucky artists who picks up everything quickly, or you might need some extra time to learn lettering. Either is exactly right. Most of us experience different learning curves for the many things we attempt. Patience is a really big lesson.

Sometimes, I feel the need to "get it" right away and have to slow down. In this book, you'll see lettering examples by artists who have spent years learning historical letterforms. Is it realistic to expect your copy to look the same as their work? Not really!

Find a table, put down some sheets of paper for padding, and begin to write. Use graph paper to begin with. Placing a sheet of Design Vellum (if your budget allows) on top of the graph paper is ideal; it provides a nicer writing surface, and you will achieve success more quickly if you do all your work—even practice—on good paper, such as Canson, Bristol, or vellum. But it is perfectly fine to use graph paper.

Ensure that the writing surface is about 18" (45 cm) from your eyes, that your feet are comfortably flat on the floor, and that your arms and elbows are at a right angle to the table. Don't sit too low or high, and don't hold your head too close to the paper. Your head weighs as much as a bowling ball and will give your lower back a huge pain, if you get too close. Good light is essential too; invest in a hook-on drafting lamp.

If you want to write on a slanted surface, you can buy a fancy-schmancy slant table or board, but a bread board propped up at a 45-degree angle in your lap works just fine. Always protect your paper with a cover sheet. This helps to keep the oils on your skin from transferring to the writing surface. Also, avoid taping your paper down. Get into the habit of moving your paper back and forth, to have your writing area right in front of your eyes.

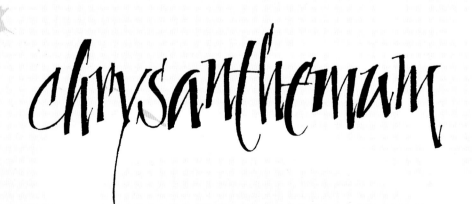

Lining Made (Somewhat) Easy

The term *lining* describes the guidelines that are used for making letters. Every alphabet in this book is made at a certain height. Historical letterforms look best when they are made at the correct height, meaning the proportions and weights of the thick and thin parts are optimal. This information may seem a bit technical, but it is important that you understand it. There is no law that says that you cannot make your letters any size you wish—in fact, I encourage this, eventually. But learn these rules of proportion at the beginning, and then improvise with this knowledge in hand.

How to Determine the Proper Spacing between Lines

The width of the pen from edge to edge is the pen width. To ascertain the best height, place the pen on its edge and measure up from the baseline. For example, italic minuscules (lowercase letters) are best done at five pen widths. Working on graph paper, and starting on the left side of your page, step up your pen on its side five widths. I recommend starting with a large edged pen. A Speedball C0 or Brause 5 mm is a great size. (Regardless of your pen size, the

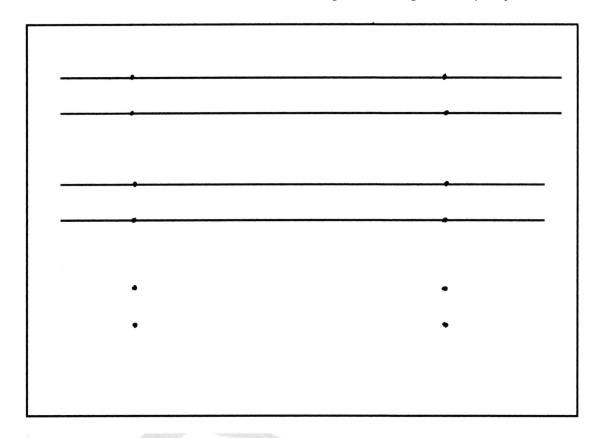

letters should always be five times the height of the pen width.)

Using a sharp 2H or 4H pencil, make a tick mark at the base and at the top of this stair-stepped height (see page 21). These will be the guidelines for the bases and tops of most of your minuscule letters. The line these letters sit on is called the baseline; the line five pen widths up is called the waistline. From your top mark, step off five more pen widths and make another tick mark. This line is the guideline for those letters that ascend above the others—the ascenders, such as minuscules *b, h,* and *l.*

Next, step off five pen widths below the waistline, being sure to stack these marks carefully and not overlap them. This lowest mark will be the line where the descending letters, such as the minuscules *g, p,* and *q,* will reach. These four tick marks indicate where to draw your four guidelines, to create your three free-way lanes for writing.

Repeat the tick marks carefully on the right. (Hint: Tick off these lines using the top of a machine edge of a piece of paper as a guide, so you won't have to measure all over again.) With an 18" (45 cm) metal ruler, lightly draw the lines between the two sets of marks. The less pencil

you put on the paper, the less you'll have to erase. To write guidelines on dark paper, use a sharpened soapstone pencil, available at fabric stores. When finished lettering, you will need only a soft cloth to wipe off the lines. (See page 28 in the Old School chapter for more information on italic lining.)

The space between the lines is called the interlinear space, or leading, which comes from the old printer's technique of creating spaces by putting slugs of lead between the lines of type. Leading that leaves a lot of space can make a piece appear airy and light, while placing the lines close together creates a look that's serious, dark, and heavy.

Plan to have margins on all pieces, even on your practice sheets. Try to see the work you do in terms of black and white (or yin and yang)—for every mark you make, you'll need a corresponding white space. Err on the side of too much white space. Think of lining as an essential part of your project, a meditation before the writing. To create beautiful, rhythmic letters, it has to be done. Accept it! Check out www.scribblers.co.uk, to find printable guidelines for practicing.

How to Fill Your Pen

You'll need to break in your nibs by taking the machine oil off the end. Swish the pen nib in your mouth. Saliva is the best grease cutter. Needless to say, you'll want to do this before you dip the nib in ink. You can also run the end of the pen nib over a lit match, but this tempers the steel, making it brittle. Your pen may still skip while you are breaking it in.

Decant the ink into a small cup, palette well, or container so that you can see where you are dipping. Make sure the ink is deep enough to place the nib halfway down into it (from the end of the nib to the beginning of the holder). Dip the pen and shake the pen back into the ink (like kitties when they get their paws wet). Work off a bit of ink by stroking the pen a few times on a sheet of scrap paper placed to the side of your work paper. If your pen has a reservoir, make sure that it is facing you, as you write. (It is usually on top; most pens have a small sheath of metal to hold the ink.)

Hold the pen loosely; don't white knuckle it. The pen should rest in the crook of the space between the thumb and first finger knuckle and not move as you write. OK, you're ready to go!

Pen Angle

The angle of the pen makes those beautiful ribbon effects and is determined by the relationship of the tip of the pen to the horizontal guidelines. How you hold the pen determines its angle. Most of the styles in this book are done at 45 degrees. You can flatten or steepen this angle to create wholly different effects with your alphabets.

Begin with "flat-tops," the name I give to a stroke that has no angle at the top and bottom—a 0-degree angle stroke. Write a row of flat tops, pulling down the strokes with even pressure across the edge of the nib and ending with the full edge of the pen resting on the baseline. Don't move your fingers; you should feel your wrist gliding down the paper. If you have ragged edges on one side of your stroke, increase the pressure a bit on that side.

Now, tilt your pen to its side, making the skinniest stroke possible (see above). This is a 90-degree stroke—it is 90 degrees higher from the horizontal line you started with. With the image of a compass in mind, angle your pen to make a 45-degree stroke, by placing your pen's right-hand corner on the waistline. Tilt the left-hand corner of the nib down halfway and pull the pen straight down, echoing the grid lines. You don't have to be exactly on the grid lines at this point, but you can trace them, if it helps. I call these Gumby-head strokes.

Do many, many of these strokes 4 graph squares high and 2 graph squares apart. When you reach the end of a line of graph paper, skip a square and begin a new row of strokes. Relax your shoulders, breathe deeply, and enjoy the process of learning.

Practicing

A wise teacher once told me that there should be no practicing. There is difference between a practice mindset and a real mindset. If we think a page of writing isn't a real or true attempt, then we won't really work at its precision. There is no such thing as just a practice sheet. Each mark you make is part of the journey. Don't even cross out the bad marks. Leave them, so you can see your mistakes!

A word on what to write. Be sure to spend your practice time with words you love. (The same applies to your projects and journals.) With so many inspirational and moving texts and quotes and so much visually rich poetry around, you needn't write only your ABC's. You can also write your own words. Life is too short to write nonsense.

Making Good Letters

Keep an eye on the shapes of the letters. If you analyze them a little, you will see reoccurring shapes, which tell you that they are in the same style. (Are they "all in the same family?" Or are there some questionable cousins?) The negative shapes the strokes make give you a good hint; are they consistent in their size and shape?

Keep your pen at a consistent angle. This trick may take some consistent practice. (Do not disregard this advice because I used the "P-word." Anything worth doing is worth doing well and can take some time to achieve.) The picket fence exercise, on page 30 of the Old School chapter, is one I warm up with before I write every day. In later chapters, I'll tell you to break this rule. But keeping your pen at a consistent 45-degree angle will create letters of the same weight and appearance.

The letters should consistently be the same slant and the spaces between the downstrokes exactly the same width apart.

There should be an underlying rhythm in your lettering, even if you are experimenting with flourishes or curls. Tether the letterforms with an ongoing rhythm, not unlike the bass line in a song.

Choose meaningful texts and uses for your letters. This will immediately ensure that your results have your personal character.

Left Handers

Many left-handed students I encounter have been told calligraphy isn't for them. Untrue! Many wonderful lettering artists are lefties, and one of my teachers, Larry Brady, is one of the finest of all. Yes, you will need special left-handed nibs, but these are easy to find online or at your local art store. These pen nibs have an oblique cut end, to help with the curves. Tilt your paper 20 to 90 degrees from your body and push it higher on your drawing board, so you can see the strokes as you make them. You will need to hold the pen at an extremely tilted angle to achieve the 45-degree stroke. Place the board in various positions, to find the one that allows you to make the strokes comfortably. Trying using the elbow-shaped pen holder that is normally used for the pointed pen but will take any style of nib, edged or pointed. The elbow-shaped pen holder tilts the pen nib to an angle that makes it easier for you to see the strokes as you write.

The elbow pen holder with left-handed nib

Chapter 3

Old School

Classical Italic
and New Variations

*I*talic lettering is the one style of lettering we are all familiar with. Our letters even slant on the computer when we press the italic key! But let's go way back to the time of the Renaissance in Italy, around AD 1500, or so. At that time, paper, rather than vellum from animal skins, began being used to create books, making them more easily available to the common man. Everyone was learning to read books, and the Italian scribes (see? italic!) needed to write them faster, to fill all the orders. The prevailing style of the day became more readable and open. Because of the quickness of writing, the letters began to slant. (This is a super-abbreviated definition of the development of italic; it did not happen overnight but over roughly 50 years.)

These characteristics have lasted almost 500 years, a solid rhythmic style with the edged pen held at an angle to achieve the beautiful thick and thin ribbon effect. When italic lettering is done well, it is beautiful, swift, and elegant. No wonder so many want to do this type of calligraphy first!

Begin by warming up with the pen angle exercises from Chapter 2 (see page 24). Trace and then copy the rhythm lines. Now you are ready for italic writing. Professionals and beginners alike should warm up with these exercises.

The underlying rhythm in italic lettering is essential. It's really like music; the spaces created by the pen, like musical notes, must be equidistant. The letters are based on a slightly tilted parallelogram, or ellipse, and are, with a few exceptions, the same width—for classical italic, this is just half their height.

Italic Basics

The edged pen nib has a flat tip. When written it will leave either a thick or thin line.

If you hold the edge of the pen at an angle and write the letters, the thins and thicks will automatically occur at the right places.

The edge of the nib should be held at a 45-degree angle to the writing (base) line.

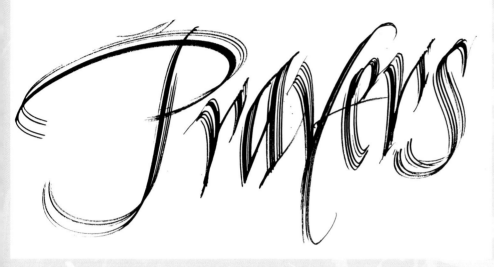

Prayers, written with a pen made of Stimudents

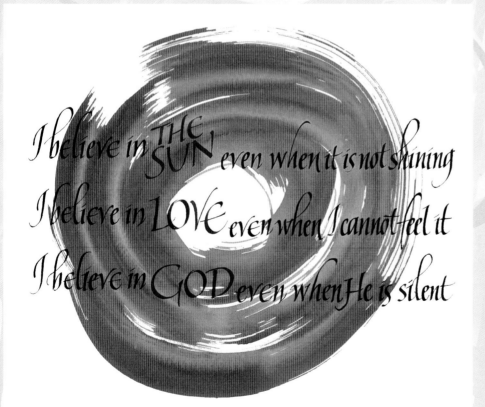

I believe in THE SUN even when it is not shining
I believe in LOVE even when I cannot feel it
I believe in GOD even when He is silent

Believe in the Sun, from the prayers calendar

Whatever
you can do
OR DREAM
you can
begin it.
BOLDNESS
has genius,
power and
M A G I C
in it.

G O E T H E

Italic sample

Italic Minuscules

Begin with the minuscule letters (commonly known as lowercase). Holding your pen at a 45-degree angle to the paper, follow the stroke sequence, always pulling down. (The ink in the pen will not flow if you try to push the edge up.) The waistline and the baseline are important! Keep the strokes exactly within these freeway lanes, creating a rhythm with consistent beginnings and endings on these guidelines. Be sure to work off the excess ink in the pen by doing a couple of test strokes on a piece of paper placed to the side of your work, or you will leave blobs as you write—not pretty!

The width between strokes is another rhythm that has to remain consistent. Practice the picket fence strokes, maintaining a width between them of about half the stroke height. A lot of discipline and patience is required to be successful at this style of writing, as it is with learning most anything. Go easy on yourself when attempting any type of lettering (or anything new!). It's good to view your work with a critical eye, but it's not useful to become frustrated. Each of us has a different learning curve—some might be able to create beautiful letters like these immediately; others might take a little longer. The most important thing is to enjoy the learning process itself, the journey to beautiful lettering.

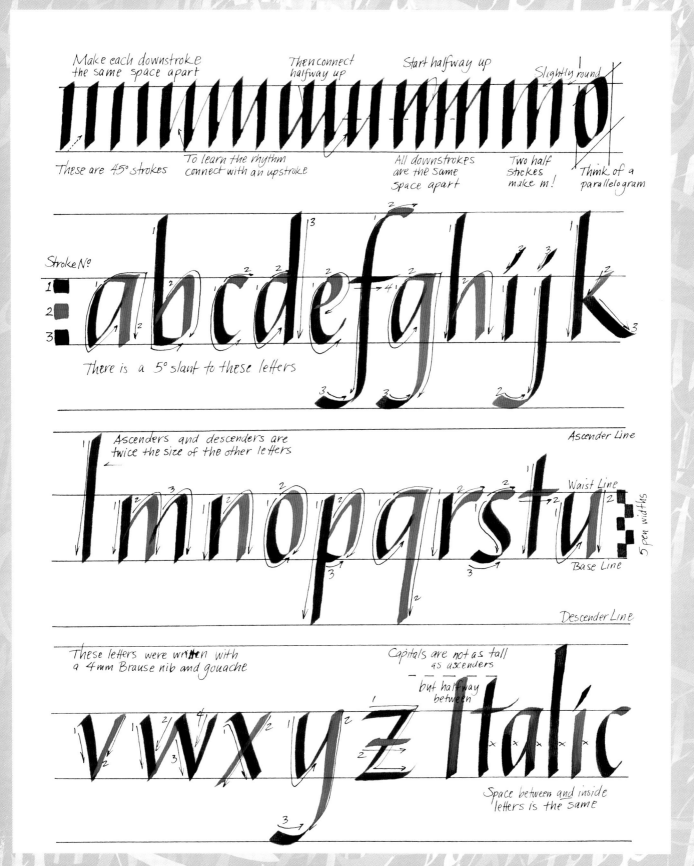

Make each downstroke the same space apart

Then connect halfway up

Start halfway up

Slightly round

These are 45° strokes

To learn the rhythm connect with an upstroke

All downstrokes are the same space apart

Two half strokes make m!

Think of a parallelogram

Stroke Nº

1
2
3

a b c d e f g h i j k

There is a 5° slant to these letters

Ascenders and descenders are twice the size of the other letters

Ascender Line

l m n o p q r s t u

Waist Line

5 pen widths

Base Line

Descender Line

These letters were written with a 4mm Brause nib and gouache

Capitals are not as tall as ascenders

but halfway between

v w x y z Italic

Space between and inside letters is the same

Lowercase or Minuscule?

Lowercase and uppercase are typographer's terms that originated in the days when type was set by hand. Individual letters, which were made of lead, were picked out of huge wooden cases. The capital letters were housed in the top case, hence "uppercase," the little ones in the case below—the lower case. It's possible that the phrase "Mind your p's and q's" originated from the use of the type case, because those letters were at the end of the case row and tended to fly off the side, if the typesetter wasn't careful. Italic-style letters, however, were created long before type was invented and were executed with a quill or reed. The letters are referred to as the capitals, or majuscules (the *major* letters), and the minuscules (the *minor* letters).

Italic Majuscules

Underlying most capitals letters are the original Roman letterforms, the ABC's we learned in kindergarten. The Roman forms are the basis of all Western letters and have remained unchanged for almost 2,000 years. Even if you only learn how to write with the edged pen at a consistent 45-degree angle, you will be able to create pretty nice italic capitals, or majuscules. (Historically, the italic capitals were written with a flatter pen angle of 30 degrees, their heavier weight giving them more importance.)

There are a few changes to the pen angle for the current style of majuscules; they will look beautiful by maintaining your pen position. Their height is a bit different than the ascending letters, because they reach only halfway between the height of the normal minuscule (non-ascending or descending) letters and the ascenders. It's easier to remember that the regular minuscules are five pen widths and the ascenders are twice that (refer to the exemplar on page 31).

The majuscules split the difference between the tallest and the shortest minuscule letters.

Keep italic capitals simple, especially if you are using all capitals. I've given you flourished majuscules here, because they're pretty, but you wouldn't want to use the flags and extensions if you are using all capitals in a title or word. Don't overflourish them. A lot of the calligraphy you see today is simply overdone. There will be more about flourishing in Chapter 11.

To create a simpler capital, just write your familiar kindergarten capitals with the edged pen. The majuscules (uppercase) letters are not as tall as the ascender letters; they reach only halfway between regular minuscule letters and the ascenders—technically they are only seven and a half pen widths in height.

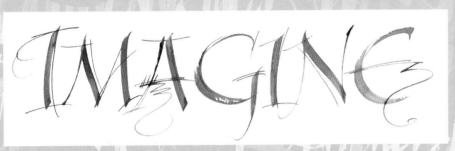

Imagine, written with a Parallel pen and walnut ink.

Letter Height

To create great contrast between the thick and thin italic letters (which is really the reason for using this special-edged pen), you must determine the proper height of the letters.

Work on graph paper. Take the side of your pen (this works for any size of edged pen) and move it horizontally, making a box. Move the pen up, touching the corner of the previous mark, and carefully step up five boxes or pen widths. This gives you the correct height of most minuscule letters. Exceptions are letters that ascend above or descend below the running lane between the baseline and waistline—these letters are called the ascenders and descenders. To determine how high or low these special letters reach, simply double your five pen widths above the waistline and below the baseline. See Chapter 2, page 31, for instructions on creating freeway lanes for ascenders and descenders.

To create a set of freeway lanes for correctly proportioned italic letters, you'll need fifteen pen widths in total: five pen widths below the baseline; five between the baseline and waistline; and five between the waistline and the top line. The minuscule *f* is both an ascender and a descender, so it spans all three freeway lanes.

Italic Rhythms

If you can maintain a solid rhythm of the down-strokes in the miniscule italic letters, you will have made a great start. Once you have accomplished this structure, you can play with stretching the letters out and playing with the width between the letters, as Denis Brown has so skillfully done here.

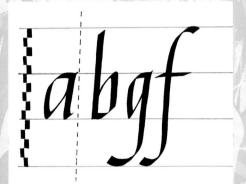

Mono Poly Rhythms, Denis Brown
Illustration of a monorhythmic italic form, based on a fixed beat pattern of equidistant parallel downstrokes and a polyrhythmic alternative that sacrifices some legibility for a more musical form. Both words were written with a 5 mm Brause nib with dynamic acceleration in many pen strokes.

The Eyes of the Lord, Lisa Engelbrecht

Circle Art: Writing in a Circle

Using a compass, scribe a circle. Starting at one edge of that circle, measure and mark your exact letter height (typically five stairsteps up), then scribe a second larger circle around the first one, using that letter height mark as a starting point. Begin writing your letters on the circle lines, as if the baseline was on a straight plane. Continue around, thinking of the hands of a clock as the backbone for your letters, and turning the paper as you write.

Alphabet, Peter Thornton

Italic Variations

It is simple to change the look of italic letters. The look of the letters automatically changes when you adjust the pen angle; the flatter the angle, the more round and open the letters rhythm becomes. When the angle is steepened, the letters compress and become pointed.

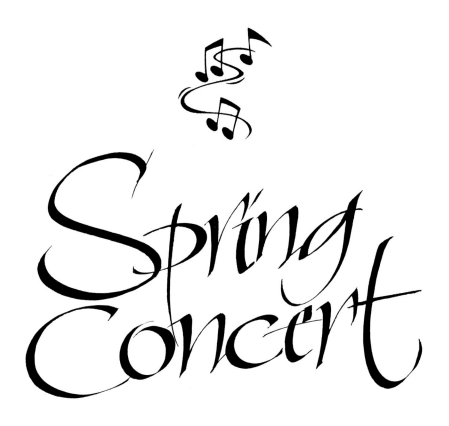

Spring Concert, Lisa Engelbrecht

A Drop or a Dot, 2007, Denis Brown
Brause nibs, gouache on paper, 10" × 29" (25.4 × 73.7 cm)

and rising

from the ground

pale clouds of smoke

float through the trees

and hang upon the air

trailing their wisps of blue

like a swelled cloak

from the round cheeks

of breezes.

Winter and Spring

Winter and Spring, Peter Thornton

Modern Mark Making

Chapter 4

Scripty

Vintage Copperplate Writing and Variations with the Pointed Pen

This type of lettering has many names: Roundhand, Engrosser's Script, Copperplate, Spencerian, and pointed pen lettering. All are quite similar, with only a few variations to each. The elegance of the graceful lines and the symmetrical beauty of this type of lettering is dazzling, and it is not easy to master. However, the same techniques learned in the script type of lettering will make beautiful modern variations, as this chapter will show!

Copperplate lettering, one of the most popular lettering styles, is achieved by using a pointed steel pen point or nib. All downstrokes are given extra pressure, so the two sides of the split nib are pressed apart, to make a thicker downward stroke. Then, as lightly as possible, the upstrokes are made hairline thin, giving copperplate its unusual and lovely contrast of dark and light. Practicing the variations in pressure is important to the traditional style and to the modern letters. For the letters to belong together, it's important to maintain a consistent weight on the downstrokes.

Copperplate lettering derives its name from earlier days, when a circular copper plate was used for printing and engraving. The plate was spun as a carving stylus was applied, creating those magical intricate flourishes so characteristic of this ornamental style of penmanship. In the eighteenth century, penmen and engrossers (engrossing means pen lettering) competed to make beautiful birds and elaborate fountains of strokes from these flourishes.

The invention of steel pen nibs in the seventeenth century was a direct influence on this style of handwriting. A beautiful and accomplished style of handwriting was considered a mark of class and a major asset in social circles. The Palmer method of handwriting, which has been used for more than hundred years in U.S. classrooms, is based on Copperplate's tall, loopy style and connected letters. The loops, however, can make speedy writing almost unreadable. Many people believe that electronic communication will soon make the skill of handwriting obsolete, although the many calligraphers, lettering artists, and people who still correspond by handwritten letters disagree.

Traditional Copperplate and Spencerian letter artists use an elbow-shaped pen holder to help them maintain the severe slant required to create these letters. The slant is 30 to 35 degrees, so proper guidelines will help you learn these letters.

Donellon Invite
Artist: Xandra Zamora

Formal Envelope
Artist: Linda Hirsh

Formal Envelope with Handpainted Flower
Artist: Lisa Engelbrecht

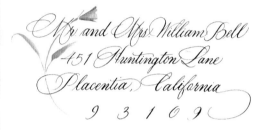

Formal Place card
Artist: Linda Hirsh

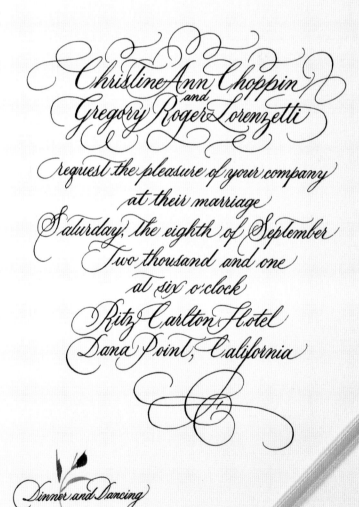

Formal Invitation
Artist: Lisa Engelbrecht

Copperplate Minuscules

Copperplate minuscule letterforms are shown with and without the stroke sequence. It's perfectly acceptable to trace these letters, to get the feeling of the style, but I encourage my students to look at the letters and copy them, because it helps develop eye-to-hand skills. I find it is faster to learn any style of letters if you copy them, instead of tracing them. You won't always have these guidelines underneath, so trace only at the beginning. You can photocopy these exemplars and use tracing paper or vellum for tracing. In fact, any method you use to feel comfortable executing these letters is fine.

Tools for Script Writing

The elbow pen holder is also a good bet for script. Any left-handed type of pen nib can be placed in this holder, to help the lefty see the letters. There are a myriad of pen points that are perfect for script lettering. The Nikko G nib, made in Japan for drawing manga comics, is perfect for a beginner to try. It is flexible enough for learning the pressure strokes and will not snag on the paper on the upstrokes. Popular types of pen points or nibs for this type of lettering include the Hunt 104, Brause 511, Hiro 100, and the Esterbrook series of pointed pen nibs. (See the Resources section, page 157, for suppliers for this pen holder and Nikko G pen nibs.)

Lining for Script Letters

For the Copperplate exemplars, I used regular graph paper with four squares to the inch. Using a 30/60-degree triangle makes it easy to draw the slant lines on the graph paper using the 30-degree side. Consistent slant is important to the look of these letters. Script letters can be made in any size at which you can still get the thick downstroke to appear. To determine the size of the ascending minuscule letters (*b*, *f*, *h*, *k*, and *l*), triple the size of the regular letters—these loops are pretty big! Leave some space between the lines of writing. A mistake I often made when I started learning these letters was not leaving enough room between the lines, the inevitable result being a collision of loops.

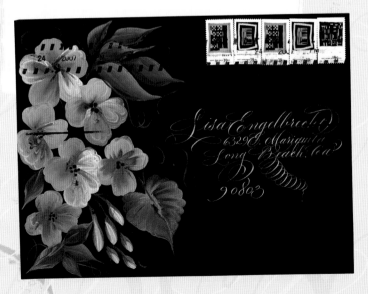

**Copperplate Envelope
with Handpainted Flowers
Artist: Linda Hirsh**

The basic strokes are...

pulldown no pressure

Press on downstroke /press /press here only

Think of writing on a balloon.

Press at top of stroke to open up the sides of the pen to make a flat top

No pressure on upstroke

release on upstroke

all one stroke - press only on the left side

Use a 30°/60° triangle to slant lines →

These letters are all connected

a b c d e f g h i j k l m n o

Use two or three sheets of padding underneath for Copperplate

p q r s t u v w x y z

start light

← press

heavy

light

Press to begin

j l l Provocateur

an alternate R

press

release

a b c d e f g h i j k l m n o

p q r s t u v w x y z

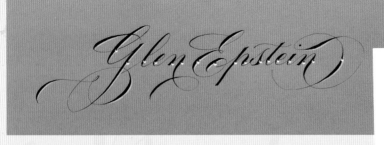

Glen Epstein

Formal Envelope
Artist: Linda Hirsh

Formal Envelope
Artist: Lisa Engelbrecht

Mr. Christian Kurt Bement
Dr. Naomi L. Bement
336 14th Street
Santa Monica, California
9 0 4 0 2

Tearston Invite
Artist: Xandra Zamora

The pleasure of your company is requested at the marriage of

Ashley Beth Tearston

daughter of Dr. Gary Tearston and Mrs. June Tearston

and

Matthew Henry Moreno

son of Mr. Henry Moreno and Mr. and Mrs. John Healy

Saturday, the twenty-sixth of August
two thousand six
at half after four o'clock in the afternoon

Saddlerock Ranch
Malibu, California

Copperplate Script Majuscules

Creating the capitals for copperplate writing is relatively simple. There are many variations to these letters. Check out *The Zanerian Manual* or the *Ames Penmanship Book* for many elaborate capitals. (See the Resources section, page 157, for more details.)

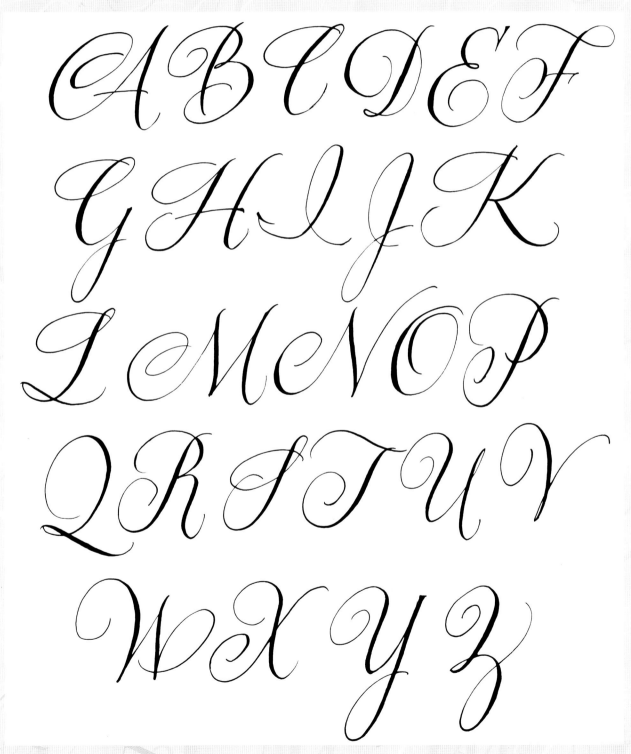

Innovation

Casual Scripts Made with a Pointed Pen

Working as a freelance lettering artist for American Greetings has opened up a world of possibilities for me for the casual style of script lettering. Using the traditional pointed pen nibs and holder and similar techniques, I twist formal writing in a new way, which produces innovative letters. The stringent rules for Copperplate and Spencerian are thrown away. (Although a good foundation in the execution of Copperplate will help these styles look even better. Please refer to the Resources guide on page 157, to find excellent reference texts and great teachers in your area.) Pressure on the downward strokes provides the thick parts of the letters, and swirls and twirls are added as needed.

Resist getting carried away with the curlicues or the curves will overpower the letters themselves. Combining your own personal script with

Copperplate techniques will give your letters a new look and create the perfect basis for casual scripty letters. You can change the slant, size, and curliness for variations on this style.

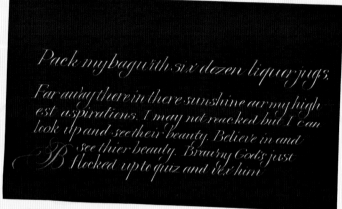

Script Variations
Artist: Linda Hirsh

Casual Script Minuscules

These letters are each done in one stroke, pressing on the downward direction. I base these on the general style of handwriting that we all learned in school. You can connect the letters if you like. The letters here have no slant, but you can certainly slant them if desired. This style is wonderful for casual invitations and cards.

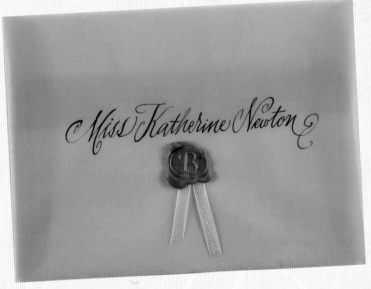

Casual Envelope
Artist: Lisa Engelbrecht

Casual Script

a b c d e f
g h i j k
l m n o p
q r s t u
v w x y z

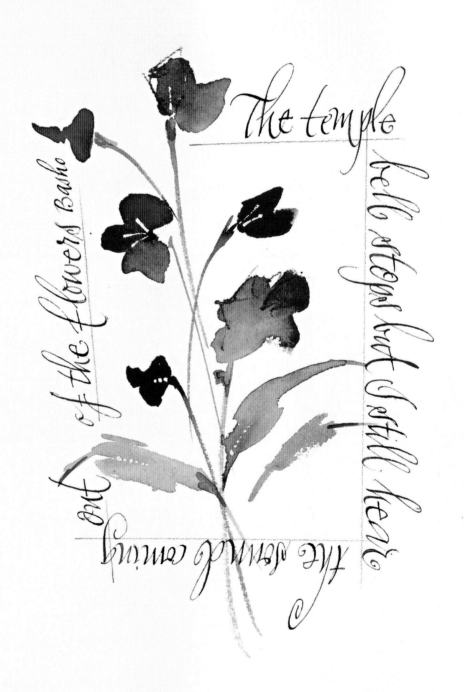

The temple

bell stops but I still hear

the sound coming

out of the flowers Basho

Temple Bells, Casual Script and Watercolor Flowers, Lisa Engelbrecht

Casual Script Majuscules

These capitals feature lots of curls, again pressing on the downward strokes for the thick bits. Not much slant is required, but you can have a lot of fun playing with the letters. Remember, to get the thins, you'll need to use almost no pressure. Imagine writing on a balloon.

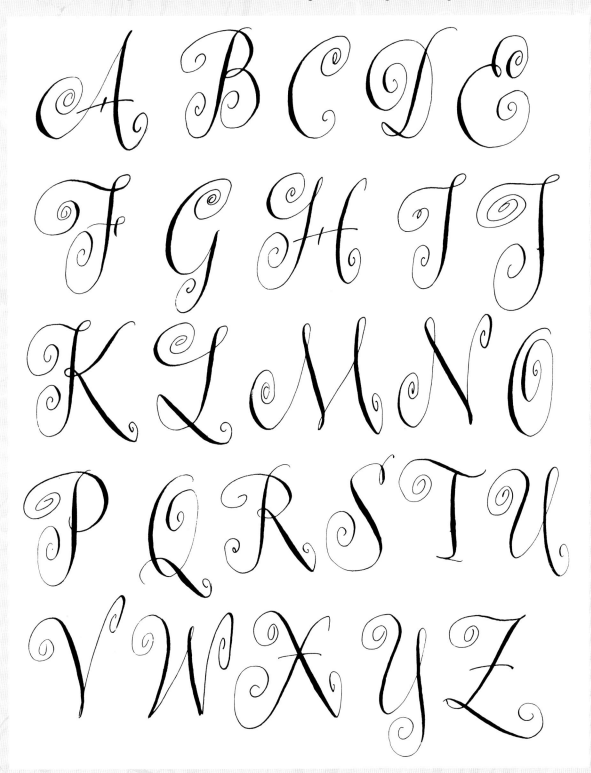

to have and to hold,
to love and to cherish

Quelque chose
pour t'aider
à célébrer
de temps des fêtes

I always have,
and I always will.

Always follow your heart...

Spring Flowers

Happy
Administrative
Professionals
Day

Pointed Pen Variations, Stephen Rapp
Stephen's excellent work for American Greetings shows only a few of his many styles executed with the pointed pen.

With Sweet Musk Roses & Eglantine there sleeps Titania sometime of The Night SHAKESPEARE

Titania, Lisa Engelbrecht
Casual script written with a Nikko G nib in Pearlescent ink

Brad Heitman
invites you to celebrate
Rachel's 40th Birthday
with cocktails and dinner
Friday, April 28
7 p.m.
at their home

Casual Pointed Pen Invitation
Artist: Xandra Zamora

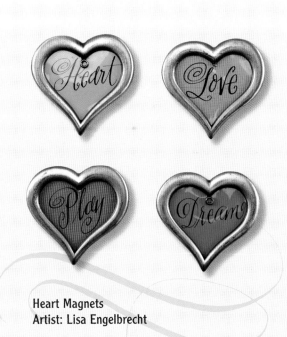

Heart Magnets
Artist: Lisa Engelbrecht

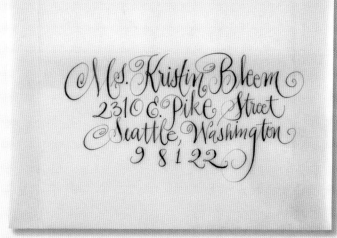

Ms. Kristin Bleem
2310 E. Pike Street
Seattle, Washington
9 8 1 2 2

Casual Envelope with Seal
Artist: Lisa Engelbrecht

Christina's Graduation Announcement

My niece graduated from film school and asked for a fun invite, instead of the formal generic kind, so casual script seemed the perfect choice.

The Newton Family

proudly announces

Christina Nicole Newton

will graduate with honors

receiving a

Bachelor of Arts degree

in Film and Electronic Arts

from

California State University

Long Beach

on Friday June 1st, 2007

at 9:00 am

Central Quadrangle

University Campus

The Newton Family proudly announces Christina Nicole Newton will graduate with honors receiving a Bachelor of Arts Degree in Film and Electronic Arts from California State University Long Beach Friday June 1, 2007 9:00 am Central Quadrangle University Campus

1) Once I received the text via email, I imported it into a writing program. I set it in a script style font and centered it, filling up the entire 8.5" × 11" (21.5 × 27.5 cm) page. I knew I could reduce it to size after the lettering was done. Plus, it's easier to write this big.

2) Using a pencil and tracing paper, I drew a rough sketch of letters over the computer printout. This served as my base. With casual script, rather than trying to be precise, I tried to be more playful and free.

The Newton Family
proudly announces
Christina Nicole Newton
will graduate with honors
receiving a
Bachelor of Arts Degree
in Film and Electronic Arts
from
California State University
Long Beach
Friday, June 1, 2007
9:00 am
Central Quadrangle
University Campus

You're Invited to
A Grad Party
and Open House
celebrating
Christina's Graduation
Saturday, June 2
5pm to midnight
16198 Little Court
Riverside

please RSVP to 951·789·0722
Don't forget to bring swimsuits & towels!

3) I pressed harder for the lines I wanted to emphasize, to make the letters bolder. Here, it's my niece's name: Christina Nicole Newton. You can also choose to make the letters a bit larger.

4) The invite for the party the following day was created in the same way. Again, I wanted to emphasize Christina's Graduation.

5) I lined the envelope with Astrobright paper and used another filmstrip sticker as a closure.

6) Here are the finished invitations. They were reduced on the copier by half to fit a 5" × 7" (12.5 × 17.5 cm) card and printed on Astrobright paper. I added a filmstrip sticker on the top to tie in with the film-degree theme.

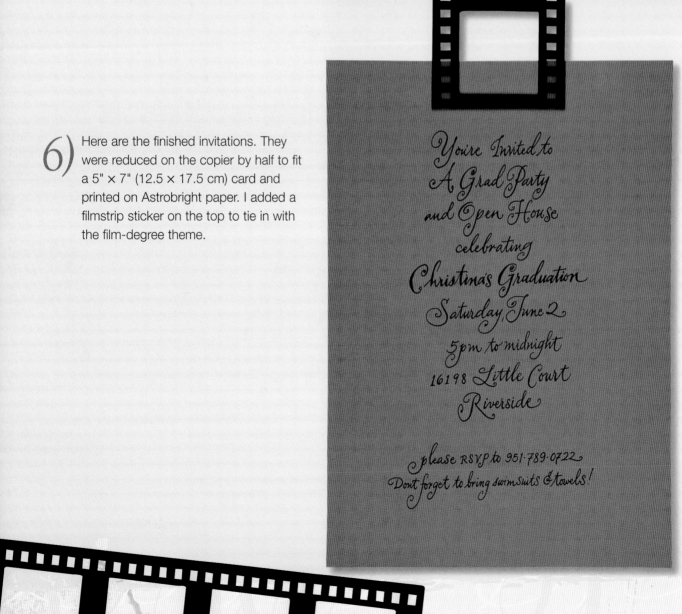

You're Invited to
A Grad Party
and Open House
celebrating
Christina's Graduation
Saturday, June 2
5pm to midnight
16198 Little Court
Riverside

please RSVP to 951·789·0722
Don't forget to bring swimsuits & towels!

The Newton Family
proudly announces
Christina Nicole Newton
will graduate with honors
receiving a
Bachelor of Arts Degree
in Film and Electronic Arts
from
California State University
Long Beach
Friday, June 1, 2007
9:00 am
Central Quadrangle
University Campus

Chapter 5

Raw Brush

Pointed Brush Letters

The brush is a universal tool and has been used in lettering for thousands of years. The Chinese have used brushes for lettering since the invention of paper. Some say the original Roman inscriptions that were carved with a hammer and chisel began as sketches using a flat brush. (This might explain the thin entrances and exits, called serifs, at the ends of the letters; they were caused by the brush as the artist began and ended each stroke.) Few lettering tools can convey the speed, emotion, and spontaneity of the brush. You can achieve a variety of weights and textures using this single tool. Contemporary brush lettering

Types of Brushes

Here are just a few of the many brushes available:

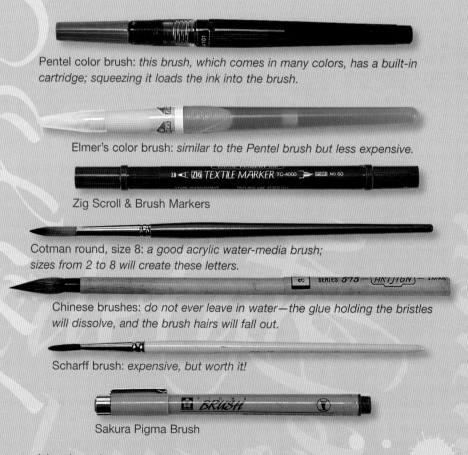

Pentel color brush: *this brush, which comes in many colors, has a built-in cartridge; squeezing it loads the ink into the brush.*

Elmer's color brush: *similar to the Pentel brush but less expensive.*

Zig Scroll & Brush Markers

Cotman round, size 8: *a good acrylic water-media brush; sizes from 2 to 8 will create these letters.*

Chinese brushes: *do not ever leave in water—the glue holding the bristles will dissolve, and the brush hairs will fall out.*

Scharff brush: *expensive, but worth it!*

Sakura Pigma Brush

A bamboo placemat makes a good brush holder for transporting brushes. Just wrap them up and secure the roll with a ribbon or rubber band.

can be seen on packaging, logos, and signage. It appears alive and fresh, almost uncontrolled, in comparison to formal pen lettering.

The weights are accomplished by applying pressure on the brush, similar to the technique used to create the Copperplate script in Chapter 3 (page 42). The side of the brush is used for the downstrokes, and then the brush is lifted to its tiniest hairs, to write the thin parts of the letter. This thick and thin variation is called shading. Shading occurs in most calligraphy. You can even see this shading in street art. Sign painters use the brush masterfully. Regrettably, the number of signs painted by hand seems to be diminishing. Their scarcity, plus the skill required to hand letter these beautiful signs, now makes them extremely valuable and unique. There is a strong and mighty contingent of those that wield a brush and still create these amazing signs. Visit www.letterheads.com to see wonderful examples.

Choosing and Caring for a Pointed Brush

The brush you use will make a difference in the look of your letters and in the ease with which you learn brush letters. Through experience, I have found that, with brushes, you pretty much get what you pay for. I learned brush lettering with inexpensive brushes, but once I tried these letters with a good brush, I was amazed at the difference in the thicks and thins of my strokes.

Look for water-media brushes. Natural hair is best, but synthetic brushes are also nice. You'll find Scharff brushes at the upper end of the price spectrum, but they are worth every penny! Sable brushes will cost even more.

The brush should also come to a beautiful thin point and have a full, rounded body to hold lots of ink, gouache, or watercolor. The point should snap back into place when shaken. In times past, good art stores had a jar of water near the brushes so you could check the brush's springiness and point. Today, most brushes are coated with glycerin, which stiffens the brush for transport and display. To get rid of it, soak your brush and gently work it out with your fingers.

To care for your brush, do not let it stand in water; this will wreck the point. Gently swish the ink and or watercolor out of the brush, squeezing the color out and carefully forming the brush into a point. Use saliva to hold this point, then store the brush upright in a cup or mug. You can also store your brushes flat, by rolling them in bamboo placemats.

The Basic Strokes of Brush Lettering

First, a few words about the Zen of the brush. It usually takes some time to get used to the feel of this tool. You may not accomplish these forms immediately, but anything of great worth is worth the time spent practicing. Put on some music, light some incense, relax, and sit down and write. Often, we want results now—it's our microwave-wired society. But, you are learning a new skill here. It took time to learn to write in kinder-garten, and it will take time to learn this, as well. Brush writing has many subtleties, which is why it is so expressive. You cannot repeat a stroke—you get but one chance. If you try to go back over a stroke, it becomes too thick and loses its liveliness. However, with practice, your hand (and muscles) will begin to remember the strokes.

Begin with the stroke practice (shown on page 61). Working on graph paper measuring four squares to the inch, make your strokes four squares high. Load your brush with ink and pat the brush on the side of the palette, as you roll it in your fingers to create a perfect point. This is a good height to practice at—however, the height of the letters is up to you. These strokes were made with a size 5 Scharff brush.

Begin on the point of the brush and push down onto the brush's belly (at least half the brush body). This makes the flat top of the stroke. In this same position, pull the brush straight down to the baseline, ending the stroke with a flat bottom. Regulate your pressure on the brush, to make these strokes the same weight.

Repeat this stroke many times, until you have an entire row of strokes that is exactly the same. (I told you this wouldn't be easy!) Add a 5- to 10-degree slant to the stroke.

The next stroke starts on the very last hair of the brush, gradually increasing the weight of the stroke in the middle of the stroke and then releasing the pressure again until you end up on that very last hair, making a C shape. Reverse the stroke and make a backwards C.

The next line of strokes are flat top and bottom slanted strokes, connected with super-skinny upstrokes (again on that last hair). Note that the downstrokes are the same distance apart. This rhythm is essential to lovely brush writing. As you learned in Chapter 3, with italic, the underlying rhythm is important to maintain.

If you start the connector strokes halfway up the stroke and repeat the downstroke twice, you'll have an *M*; just one connector makes a *N*. The *O* is the *C* stroke continued upward in an oval. Horizontal strokes are tricky, and you may need to place your hand underneath the stroke and move it like a windshield wiper, to the right. The final flick strokes are done quickly by pulling the brush down and lifting off the paper quickly. (Note to left handers: Tilt your paper, so the baseline is at a 90-degree angle to your body. You'll be able to see the strokes and can do them by pulling the brush away from you. It can be tricky to see the letter construction—check the letters by moving the paper to an upright position.)

Minuscule Brush Letterforms

Be sure your body position is comfortable and natural; avoid hunching over your practice. Hold the brush loosely in your hand. Begin with the A, which, as you can see, is created from a combination of the two strokes you warmed up with. All the letters are combinations of the warm-up strokes. You can use tracing paper or, even better, vellum to trace these letters. Regulate your pressure and try to give equal weight on the downstrokes to give the letters a uniform look. Don't stress over the perfection of these letters; the brush should convey spontaneity and freedom.

abcdefgh
ijklmnop
qrstuvw
xyz

abcdefgh

ijklmnop

qrstuvw

xyz

Majuscule Brush Letterforms

The majuscule brush letterforms are composed of the same strokes shown on page 61. I made these letters five squares high, using the four squares-to-the-inch graph paper and a size 2 Scharff brush. Almost all the strokes in brush are pull strokes, from top to bottom. The upward strokes are always made on the last hair of the brush.

A B C D E
7 G H I J K
L M N O P
Q R S T U
V W X Y Z

Society for Calligraphy

Society for Calligraphy
Artist: Stephen Rapp

Greetings

Greetings
Artist: Stephen Rapp

*I always have,
and I always will.*

I Always Have
Artist: Stephen Rapp

Casual Brush

a b c d e f g h i
j k l m n o p q r s
t u v w x y z

Casual Brush

A B C D E F G H I
J K L M N O P Q R
S T U V W X Y Z

The brush holds so many possibilities for cool, casual lettering. Just doing some loose scripty writing with the brush will give you a great look, as shown here in the exemplar. If you remember the pressure of the formal brush letters, you can adapt them randomly to a freer style, as in the invitation shown at right.

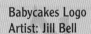

Babycakes Logo
Artist: Jill Bell

This style of brush lettering is accompanied by images made by small stamps, hand carved from erasers. The letters were loosely aligned and written without planning. The bride and groom hand stamped their envelopes for a fun addition to the brushy, less serious letters.

Mrs. Sharon Gullikson
and Mr. Brian Poteraj
200 Mariquita St.
Long Beach, California

Susan Tallpen

Spring Flowers

Spring Flowers
Artist: Stephen Rapp

Brush Samples

Writing is another meditation that is frantic compensation. I'm putting some of myself to sleep, trusting the end of my days: There's a death wish in reducing life to watching one's fingers twitching on the alphabet. JONATHAN LETHEM

Writing Is Another Meditation
Artist: Carl Rohrs

to have and to hold,
to love and to cherish

To Have and to Hold
Artist: Stephen Rapp

Norah Jones
Artist: Jill Bell

Norah Jones

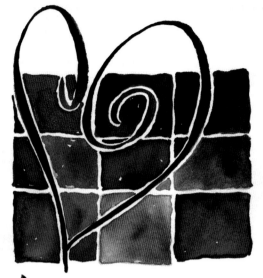

I Love Thee
Artist: Barbara Close

Veronica
Artist: Carl Rohrs

Lottie Carsko
Artist: Carl Rohrs

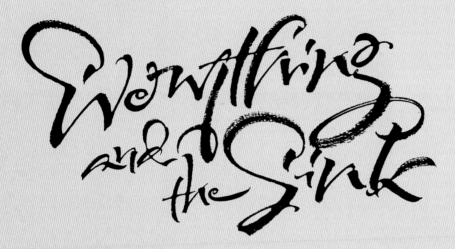

Everything and the Sink
Artist: Carl Rohrs

kalligraphia
Artist: Carl Rohrs

Glamorama
Artist: Jill Bell

Jill Berry, Sharon
Artist: Carl Rohrs

Alphabet
Artist: Carl Rohrs

Chapter 6

Scrawly

Rough and Edgy Letters from Everyday Pens and Brushes

The use of handwriting in advertising is extremely popular today. Advertisers are using loose, scrawly words to promote almost everything, probably because the letters seem real and accessible. The well-trained lettering artist might find it a bit difficult to create the scrawly type of lettering. The previous chapters in this book have emphasized rhythm and precision. To scrawl, however . . . well, you simply let go. There is a grace, though, to a good scrawly word, the human mark.

The tools you use determine the character of your marks. You might even want to combine a couple of tools, to create even more character. Try pen nibs of all types, brushes, smudgy pencils (Staedtler Mars Ergo, for example), and perhaps crayons. As you will see in the samples, the best marks are intuitive and spontaneous. Scrawly is immediate and, at times, radical. It is truly a DIY style of writing. The meaning of this mark is still paramount. It is essential that you be connected to the words, that you feel them as you write, as you make your mark.

Scrawly style's roots go back to the last century. They were a rebellion against the typeset style of the day. Handmade letters were popular during the sixties' psychedelic era—remember the "War Is Not Healthy for Children" poster by Lorraine Schneider? Punk poster creators reveled in the antiestablishment tone that the scrawled letters provided.

The characteristics of this style of writing are defined by its irregularity. Keep it uneven, scratchy, and loopy. Begin by handwriting with your chosen tool. Drip the ink or leave blobs as you make the letters. Have fun with this type of writing. It will be a distinctive addition to your repertoire. Copying these samples will give you a good start, and be sure to note the tool used for each one. Old brushes are especially good, but almost anything can be a lettering tool. An old shaving brush is one of my favorites. In the Street chapter, on page 108, you will find instructions for making your own lettering implements.

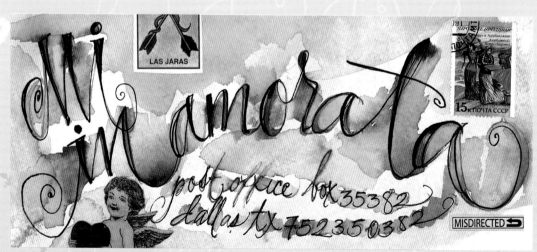

Pointed brush, mixed media, and watercolor

Your life is the one place you have to spend yourself fully-wild, generous, drastic-in an unrationed proflagration of self.

Pointed brush with colored marker

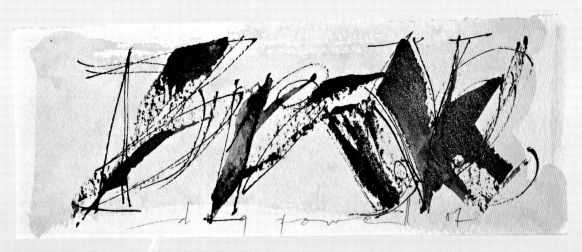

Brave
Artist: Deborah Powell

Monoline-o-mania!

a b c d e f g h i j
k l m n o p q r
s t u v w x y z
A B C D E F
G H I J K L
M N O P Q
R S T U V
W X Y Z

You are
Not
Meant
for
Crawling
So
don't.
You have
WINGS
Learn
to use
them
and FLY
r u m i

Rumi quote, done with
Sakura Soufflé pens

Monoline means "single line." There are no thick
or thin parts to the letters. You do not need a
fancy calligraphy pen to make these cool letters.
This is an exemplar of plain old letters with a
funky twist. Make the caps bigger and bounce
your letters. Add a curl here or there, wherever it
feels right. These letters were done with a tiny,
fine-point Micron pen. This is a great alphabet
to play with when you find yourself stuck in an
airport or waiting room. A Rainbow pencil is fun
to use with this style. The quote on the left was
done with Sakura Soufflé pens, with no planning
or guidelines.

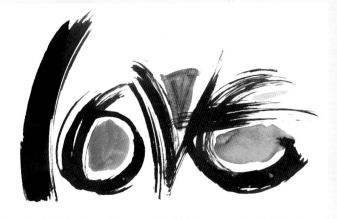

Love, done with an old paintbrush

Manka's
Inverness Lodge

Mankas Inverness Lodge
Artist: Jill Bell
Pointed brush

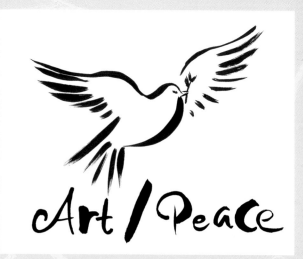

Art/Peace

(Left) Art/Peace
Artist: Jill Bell
Pointed brush

(Below) Some Things
Artist: Stephen Rapp
Pointed brush

HAVING CHEWED
ALL THE Cocktail limes
Down to the RiNDS,
Mary REALIZED
She SHOULD have Eaten
before she Came.

The Cocktail Limes
Artist: Stephen Rapp
Pointed brush

Some thingl were simply meant to be.

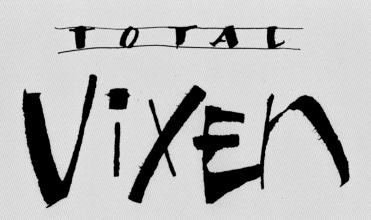

Total Vixen
Artist: Stephen Rapp
Edged pen

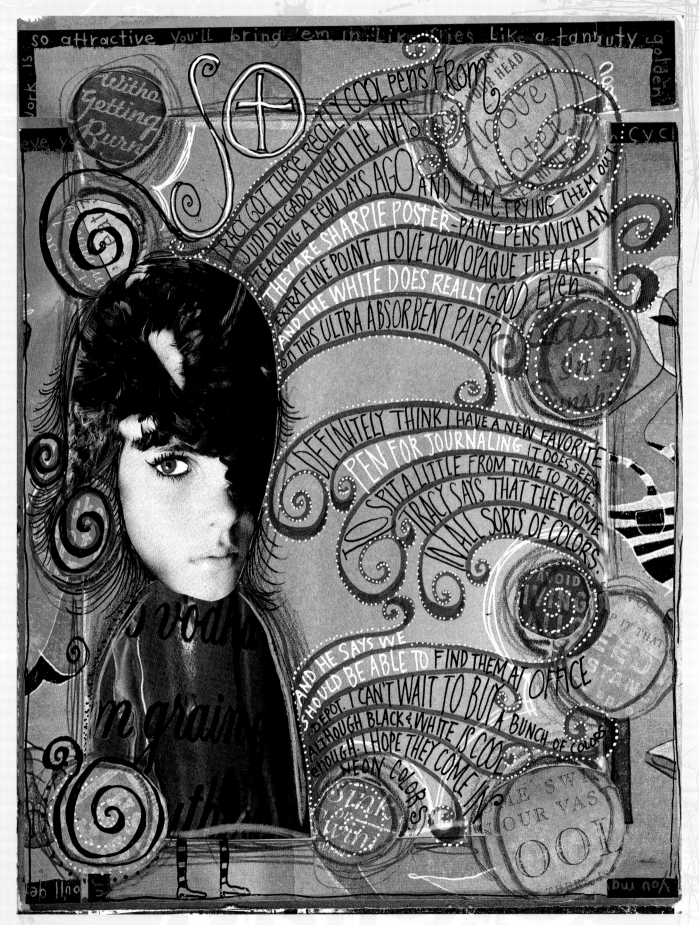

So, Artist: **Teesha Moore** Sharpie poster pens and mixed media

Chapter 7

TRICKY & FUNKTIONAL

Play with Your Letters

Play is a very important part of life and lettering. I find it exciting when I twist or skip my pen in a new way or try a new implement I've found. Here are some discoveries I've made. The traditionalists may not agree, but, personally, I feel that if I'm going to letter, it's important to enjoy the process. There was always something about formal writing that held little sway with me. Developing a personal style is born out of this kind of play.

To create this type of letter, I take the edged pen tool—the Speedball C series, the Brause nibs, or the Parallel pens—and I start with the traditional italic letterforms from Chapter 3. I love to blend colors, and I use gouache, watercolor, acrylic inks—whatever is mixed up and nearby!

Dream

Variegation Using Gouaches and Watercolors

I tend to use bright colors just because I like them. When I studied two-dimensional design in college, I color-mixed my head off and learned tons about complements and 15- and 30-minute intervals on the color wheel. There are plenty of classes and books on color, but, for me, it comes down to simply using what I like and not being afraid to mix it up. I urge beginners to not try to combine more than three colors, though. I do remember one rule: Any three colors mixed make a mudlike color. But it could be a beautiful mud! How will you know unless you try it? If it's off, try again. How will you know success if you don't first experience failures? Make failing part of the learning process. It can be incredibly frustrating to experiment with color and to replicate results with letters. The craft of lettering is one huge lesson in patience.

Choose three colors of watercolor or gouache in a tube and add a dab of each one in the well of a plastic palette. Add some water to the well, but don't mix the color, rather, let the colors drift together naturally. This will give you some great watercolor-effect letters. (Be sure to see Resources, page 157, for my favorite book on color mixing.)

Try This!

Skipping

Skipping: Lift the pen midstroke, leave a small stroke, and continue.

Extreme

Skipping Extreme: Lots of skips!

Rock'N'Roll

Rock 'n' Roll: Rock the pen from side to side midstroke.

Diamond Life

Diamond Life: Pick up the pen midstroke, make a diamond, then continue.

Experimental

Experimental: When the ink is dry, use a white correction pen (such as Wite-Out) to make random lines across the strokes.

Chameleon

Chameleon: Blend two colors.

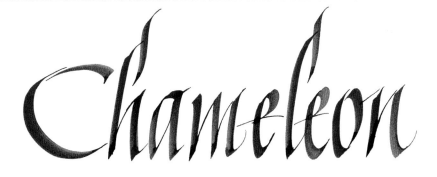

Chimera

Chimera: Layer colors. After writing in one color, go back halfway up the downstrokes with a darker color and layer stripes and lower parts of strokes.

A B C D E

F G H I J

K L M N

O P Q R S

T U V W X

Y Z

Funky Minuscules

Inspired by my friend, Traci Bautista, these are italic letters that went free for all. There are no rules for creating these letters, although there is a bit of an angle to the pen, probably about a 45-degree slant. See how these letters would change if you didn't tilt your edged pen at all! The Parallel pen by Pilot is ideal for the twisting and making the fine lines and tendrils. I've also incorporated some skipping and wiggling. You have total permission here to have fun with these letters.

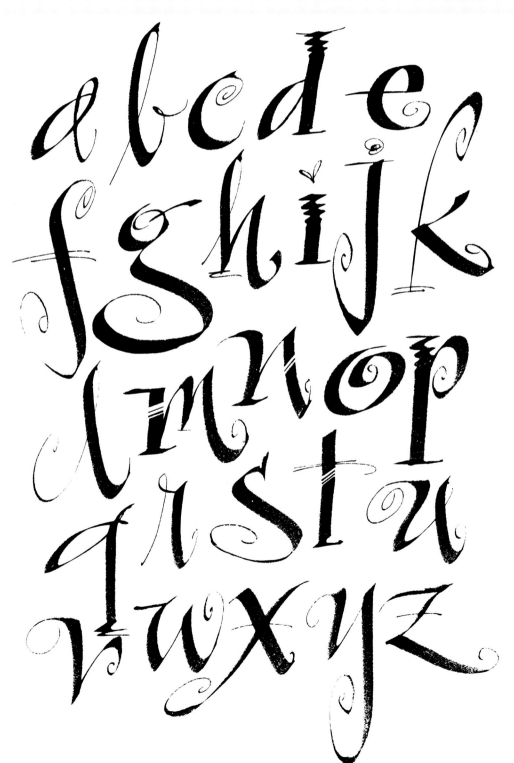

Try to mix up the variations shown on the previous pages and come up with your own. Remember that developing your personal writing style is important and that there are no rules in this type of lettering. Oh, wait! There is one rule—to have a lot of fun and enjoy yourself. Here are some samples of some other ways to play.

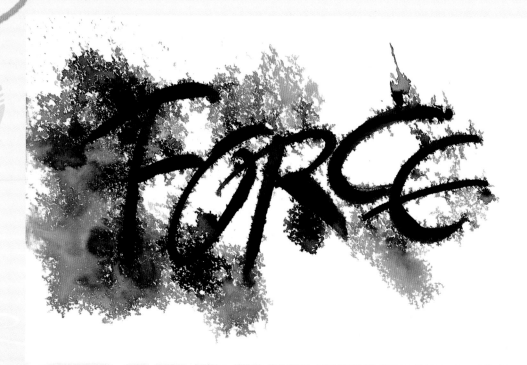

Force: While the ink is still a little wet, spray it with water, using a mister bottle.

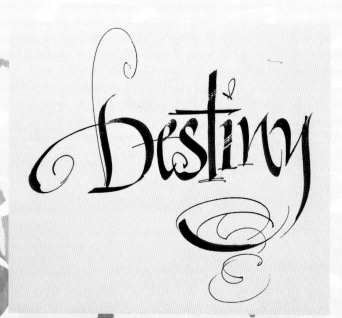

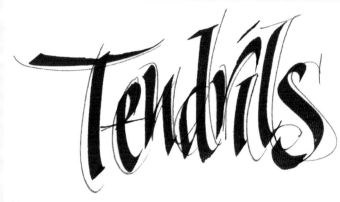

Tendrils: Tiny tendril lines are made with the corner of a Micron pen.

Destiny: This is a combination of variegation, metallic powder, skipping, and tendrils, plus a little bit of play!

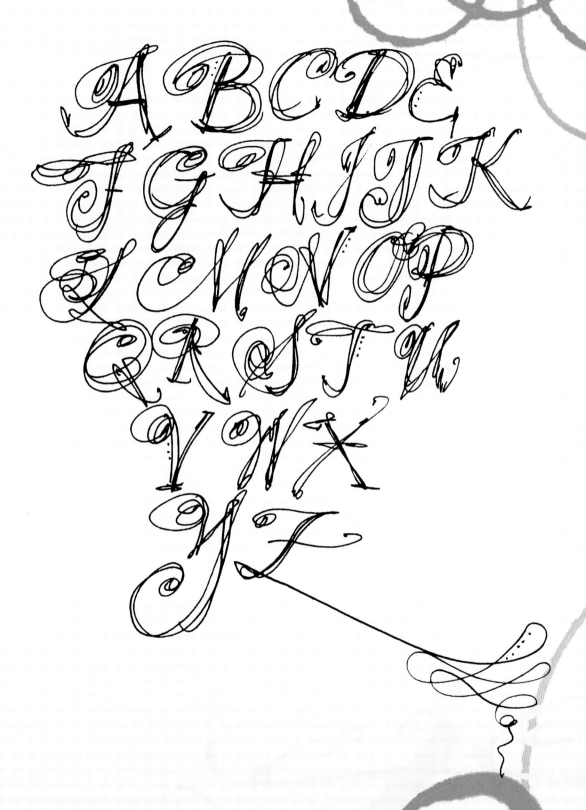

No-Lift Letters: Here, each letter was made without lifting the pen.
Use a monolinear tool, such as a ballpoint or Micron pen.

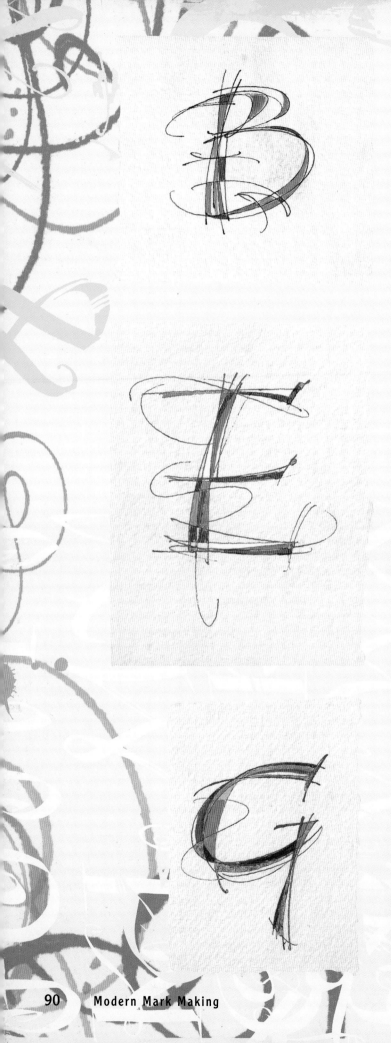

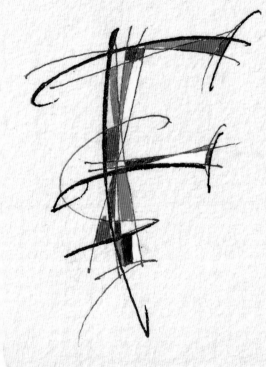

Taking no-lift letters a step further, these letters were made with a gel pen, and the spaces were filled in using different types of Sakura gel pens: Soufflés, Lightnings, and Glazes.

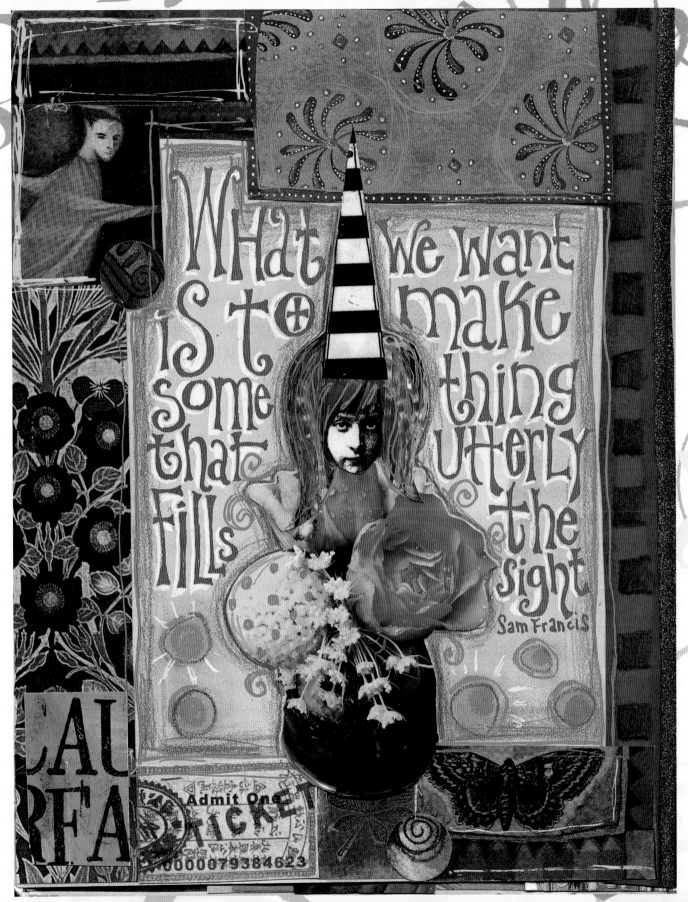

Something That Utterly Fills the Sight
Artist: Teesha Moore
Collage and hand-lettering. These letters were written, then built up by going back over them, thickening parts and adding a shadow of yellow.

Loveliness

Rainbow Pencil

Rainbow pencils and a Micron pen make easy, lovely letters.

Letters Extreme

Lisa
Artist: Deborah Powell
Gouache and Micron pen

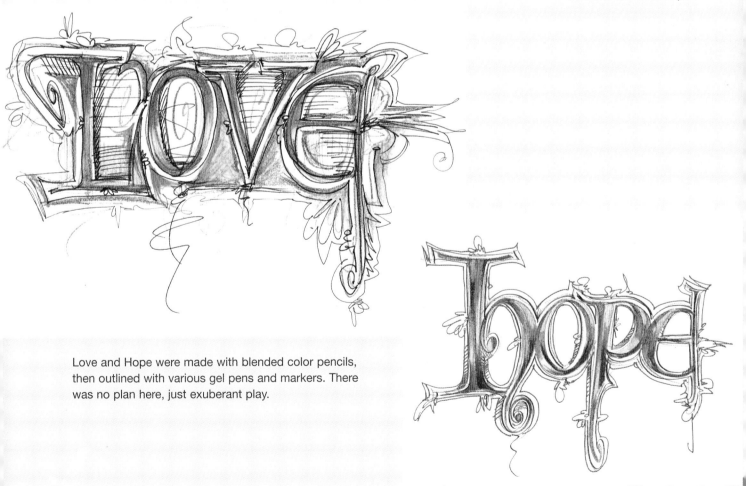

Love and Hope were made with blended color pencils, then outlined with various gel pens and markers. There was no plan here, just exuberant play.

Modern Mark Making

Chapter 8

Stitched

Lettering with Fabric
and Stitchery

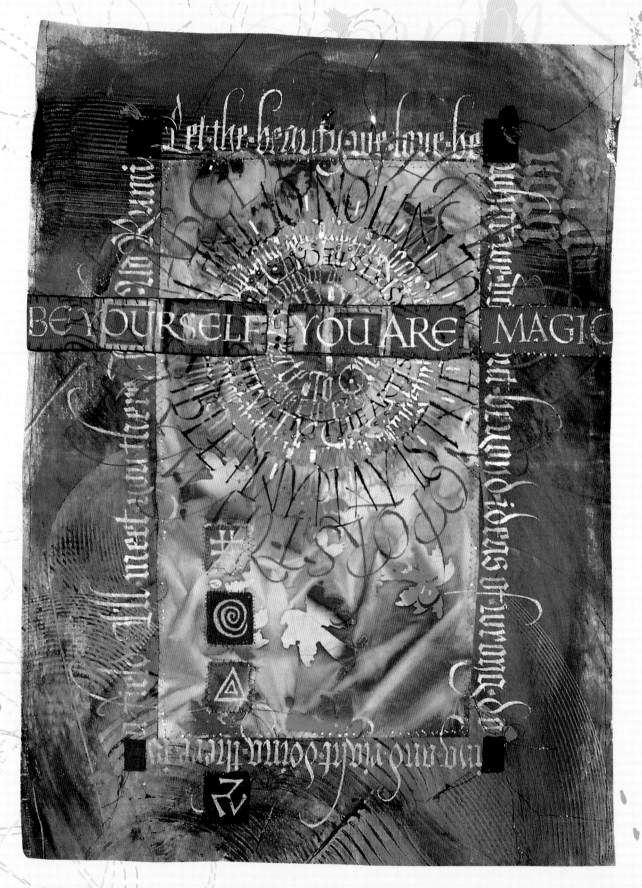

Be Yourself
Artist: Lisa Engelbrecht
Acrylic inks, paste papered canvas and collage elements

Writing on fabric is a wonderful surprise. I first wrote on fabric during a workshop with the wonderful Charles Pearce. During my studies with Marsha Brady (not of TV fame, but simply the best lettering teacher in the world), I was given a project that involved writing on a large piece of paper. Taking the easy way out, I lettered on fabric. I immediately loved the surface: the pull, the fighting with the fabric, and the fact that I got a second chance at a letter if I wasn't perfect on the first attempt. (The ink doesn't always cover completely the first time you letter, so you often have to go back and stroke it twice.)

I lined my fabric with pencil and later found it was not really erasable. Then I learned of the purple disappearing-ink pens made for quilters and immediately put one to use in my work. Letters created with acrylic ink are permanent and washable. This is a wonderful technique for any fabric item, such as pillows or placemats. I now use writing on fabric in almost all my artwork, by incorporating fabric, collage, and stitchery.

The easiest fabrics to write on are 100-percent cotton. Lightweight muslin is smooth enough for beginners but is so light that it must be backed, which you can do by ironing muslin or any lightweight fabric to the shiny side of freezer paper (available near the foil and plastic wrap in the grocery store). Canvas fabric is also a good choice for lettering. It is available at most art stores and comes in different weights (7 ounce, 10 ounce, and 12 ounce) I prefer the smoothest unprimed canvas available and

Unbleached muslin

usually find that a heavier weight gives a smoother surface, although this is not always the case. You won't need to back the canvas with freezer paper; it's already thick enough.

Do not wash the fabric before you write on it. Newly purchased fabric is coated with a sizing that grabs the acrylic better. However, by not washing out this sizing, there is a chance that the writing will not be as permanent as you like. In my trials at home, though, I have never been able to wash acrylic ink or paint out of my fabric!

Tools for Lettering on Fabric

- purple disappearing-ink pen from Dritz, to draw lines
- Dip calligraphy pens: all kinds, even pointed pens
- Zig calligraphy markers—(there are other felt calligraphy pens, but I like Zig markers because they are lightfast, pigmented, and long lasting)
- Textile pens
- Flat or pointed brushes
- Colored pencils and pens
- Gel pens
- Sharpies
- Sharpie Paint Markers

Media for Letters

(Use these straight out of the bottle.)
- FW Acrylic Ink by Daler-Rowney (you'll find these in the airbrush section of the art store)
- Pearlescent Liquid Acrylic Ink by Daler-Rowney: lovely shiny inks that are beautiful on dark fabrics
- Speedball Super Pigmented Acrylic Ink
- Gesso (an acrylic primer): use on canvas before or after washes of paint or ink (to make a wash of color, add water to any medium and use a brush to wash the page with it)

(Dilute these with water or textile medium)
- Golden Heavy Body Acrylics
- Dr. Ph. Martin's Spectralite Airbrush Color
- Jacquard Neopaque and Lumiere Textile Paints (I love the White Neopaque for letters.)

Note: You can seal washes of these inks and paints with No Flow sealer from Jacquard.

Lettering on Fabric

1) Using the purple disappearing-ink pen and a ruler, line your fabric. You can also design your placement and letters with this pen, because it will magically disappear in about a day, depending on the humidity.

2) Decant the ink into a plastic palette or small cup. Load the pen with acrylic ink, filling the reservoir about halfway. Shake the excess back into the well. Try a few letters on a piece of scrap fabric. Go over the outline of the letter. You will likely have to go back over the stroke to cover the fabric completely, but this gives you a chance to perfect the letter. Writing on fabric will be slow going, at first, but eventually you will get used to the new surface.

3) To create a variegated effect, dip into two or more colors. Keep a well filled with water and dip into it occasionally, to keep the ink flowing. When you are finished lettering, be sure to clean your writing instrument well. Use an old toothbrush to get all the acrylic out of the pen, to keep it from being ruined when it dries.

4) In about a day, the lines will disappear and—voila! You have written on fabric. Peel off the freezer paper and sew the piece onto your background fabric. (The freezer paper can be recycled.)

Stitchery, Fabric, Letters, and Collage

My first foray into fabric collage came about when I was unhappy with my lettering and decided to layer another piece of fabric on top and stitch over it. My mistake turned into collage! Again, there are no rules here. I use a simple straight stitch and actually pull the fabric to "write" the letters with the machine needle. I am not trained as a seamstress or quilter, although I greatly admire the patience and beauty of handmade quilts. The rough and raw edges seem fine to me, though you might want a more finished look, with turned edges. You might also want to use fabric to create book pages. A simple pamphlet stitch is all you need to hold the pages together.

My Grandmother
Artist: Lisa Engelbrecht
Acrylic ink

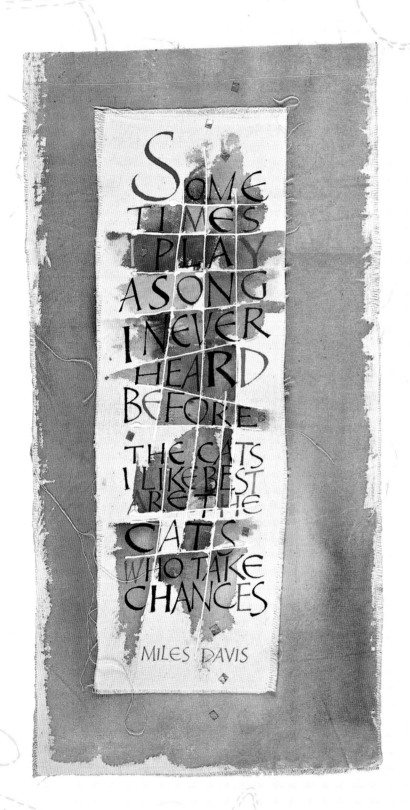

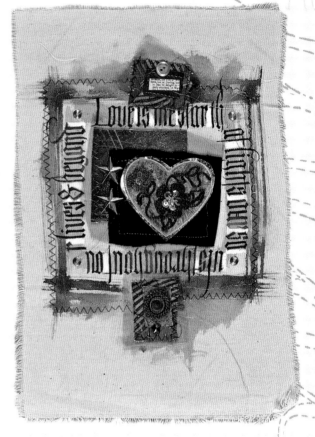

Love Is the Star
Acrylic and walnut ink, mixed media on unprimed canvas

(Left) Sometimes I Play a Song
Acrylic ink and dimensional T-shirt paint for the white lines, on unprimed canvas

The She Leaves Project

The day my mother died was the day I found out I was pregnant with my first child, my daughter Kristin. With this project, I wanted to preserve the small stories, mementos, and bits of history about my mom that my daughter would never know, unless they were collected together and celebrated. Along with fabric and photos, I used the above-mentioned techniques to letter my stories onto the fabric squares, creating "leaves" of memories. The vintage photos were transferred to fabric with photo-transfer paper and then sewn or collaged onto the original color-washed fabric. I used walnut ink for the background washes, to give the fabric an aged look. These are but a few of my mom's leaves; I've finished quite a few, and there are more to come! We will store them in a beautiful, square wooden box.

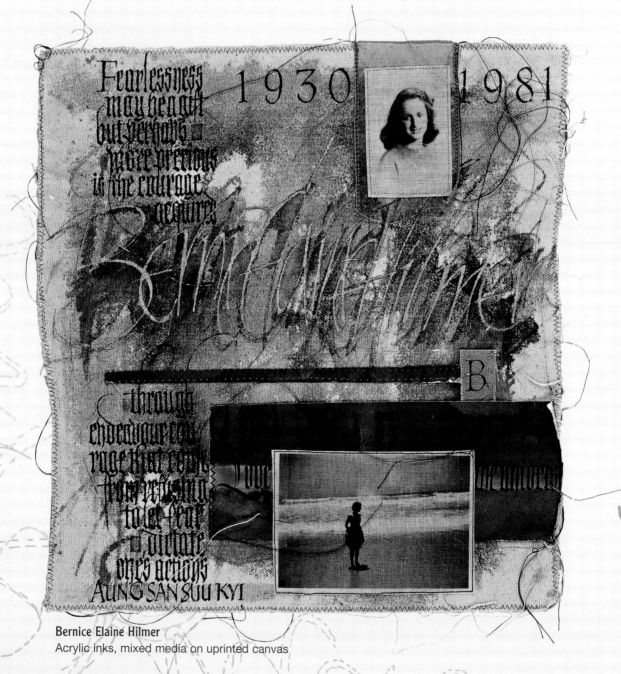

Bernice Elaine Hilmer
Acrylic inks, mixed media on uprinted canvas

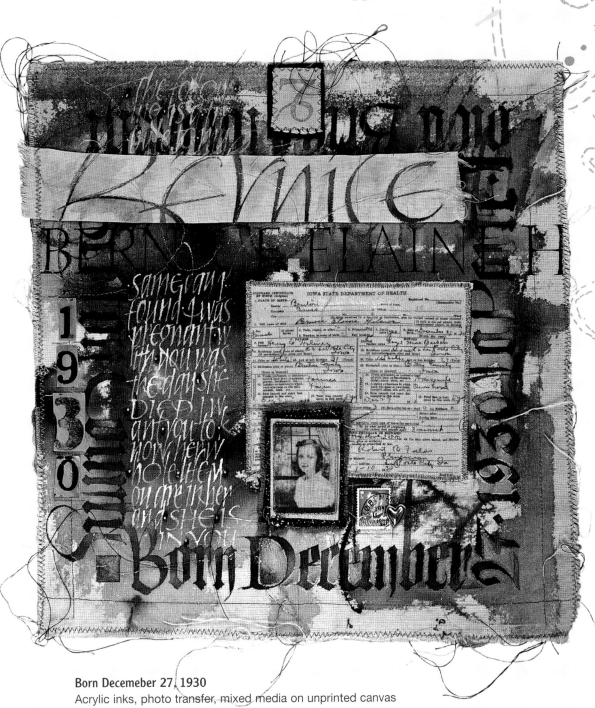

Born Decemeber 27, 1930
Acrylic inks, photo transfer, mixed media on unprinted canvas

Graffiti is one of those buzz words that make people uncomfortable. Graffiti (from the Italian word *graffito*, meaning "scratched") was found in the ruins of Pompeii and was probably around even before it was discovered there. One of the preserved inscriptions from Pompeii reads: "I am amazed, O wall, that you have not collapsed and fallen, since you must bear the tedious stupidities of so many scrawlers." The cave drawings at Lascaux in France are a form of graffiti, if you think about it, just a type of communication. What is today's graffiti artist, tagger, or calligrapher trying to say? Is it indeed only vandalism?

The term used in street circles for creating graffiti is "getting up." This means being seen, writing your name every-where, gaining a name for yourself. Is this so different from what most artists do? I love to tell the story of the Native American elder who visited Los Angeles for the first time. He saw the many walls of graffiti on the sides of the freeway and said to his host, "Your children are crying."

So, now, to my disclaimer: I do not condone or encourage any illegal defacement of private property. But, maybe we need to invest in art programs in urban areas, to give these artists outlets and opportunity for this expression—places in which they can make their marks.

The roots of graff (short for graffiti) are pure and raw. This is mark making at its purest. The styles seen are inventive, colorful, and innovative. "Piecing" (short for masterpiece) is the term graffiti writers use for these beautiful, intricate works. There is a fascinating culture created by these artists. The street influence can be seen in popular culture, in fashion and packaging, probably to the dismay of the original artists. As in the calligraphy world, some graffiti artists are renowned and have many admirers and imitators. However, stealth and anonymity, which are seemingly incongruent to "getting up," are necessary to avoid prosecution. Even so, many street artists are now finding that gallery shows and merchandising are part of their art life. Many artists, such as Thomas Ingmire, whose background is rooted in traditional hand lettering, and Jose Parla, whose art is inspired by the street, are blurring the lines between fine art, lettering, and graff.

The most inventive graff I've seen lately is from the Seventh Letter Crew (the seventh letter of the alphabet being *G*, for graffiti). Their inventive, fantastic, mind-blowing colors and letters can be found on the streets of Los Angeles.

Hand styles are the names given to the writers' signatures. These signatures are fascinating. Just trying to decipher the letters is a trick. The artists pride themselves on their ability to create intricate and almost illegible designs. The sheer imagination these artists convey in their work is a great source of inspiration for me, and I feel other lettering artists could learn a trick or two from them, too. (For more information, see Resources, page 157.)

LETTERING/DESIGN

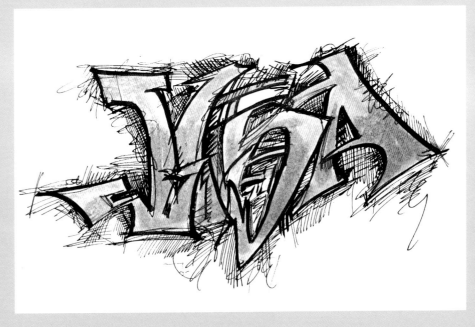

Urban Style: Easy-to-do Graffiti

I'm "totally being a toy here," (that's street slang for "inexperienced and incompetent"), but here is one way to play with your letters, to get that "stupid fresh" look.

1) Using a Parallel pen for easy play, write your words at a 45-degree angle.

2) Alternate between using capitals and lowercase, overlap and crack the stem strokes, fitting them into the spaces. Intuitively feel this!

3) Slant the stems of the strokes back and forth.

4) Outline the letters with a monoline thin pen, such as a Micron or Pitt pen.

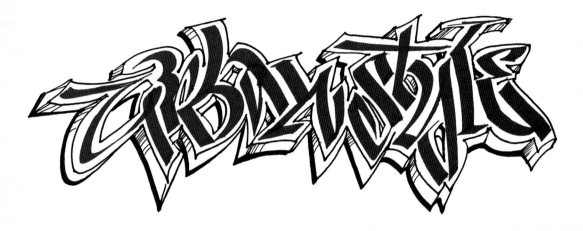

5) Go all out and repeat the outline. Here, I used a calligraphy felt pen to shade the letters and a Micron pen to add some shade strokes. You are simply exaggerating and playing with the letter shapes.

Bliss
Artist: Traci Bautista

Do-It-Yourself Cool Tools

You have to admire the ingenuity of street artists who invent their own tools for writing. To create an instant tool, all you need to do is find a common shoe polish dispenser, glue stick, or deodorant container, empty it out, fill it with ink, and top it off with a chalkboard eraser "nib." To obtain a lovely, drippy effect, add paint thinner to the ink, as you go.

Letter artists and calligraphers have also invented their own tools. An artist should know how to create and control their tools. Here are a few to try. You may find yourself looking at foam brushes and wooden shims as possible lettering implements. (Anything with a broad edge will work!) This tool is a great substitute for the more-expensive poster pens available.

Yogurt Container Pen

Materials:
- plastic container, such as a yogurt or sour cream container, cleaned well
- scissors
- stapler
- pencil
- masking, electrical, or duct tape

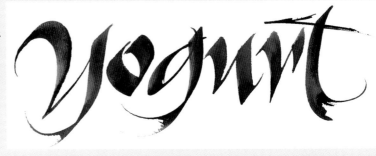

1) Cut two shovel shapes to the desired width of the "pen." The handles should be about 2" (5.1 cm) long and as wide as the pencil.

2) Staple the two pieces of the nib across the end, about ¼" (6 mm) in.

3) Press the point of the pencil into the staple and tape the two sides to the pencil. Cutting one or more V's into the end of the nib will give you a scroll effect as you write.

4) Dip the pen into a deep well of ink, or load ink from the side.

Stimudent

Stimudent Pen

Materials:
- *package of Stimudents, found at most drugstores in the dental aisle*
- *sharpened pencil*
- *masking, electrical, or duct tape*

1) Stimudents are used for stimulating your gums, but they also make a great pen. Choose how wide you'd like your nib and break off this number of Stimudents from the row. Do not separate them!

2) Use the tape to lash the sharpened end of the pencil to your Stimudent group, leaving the pointy ends out.

3) Soak the Stimudent pen in water briefly, then dip into ink or gouache. Writing with this tool creates a wonderful scroll look.

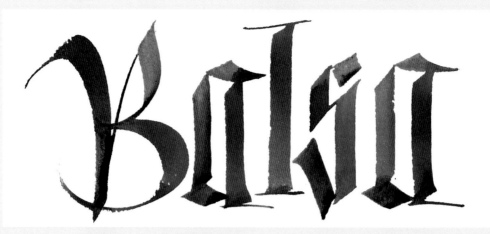

Balsa Wood Pen

Materials:

- *foam brush with a clear plastic strip resting in a notch underneath, to support the foam*
- *small piece of balsa wood (or roofer's felt or doll house shingles)*
- *Krazy Glue*

1) Remove the foam from the brush and, using a knife, carefully remove the staple holding the clear plastic form in the notch. Remove plastic.

2) Cut a piece of balsa wood to your desired pen width and about 1½" (3.8 cm) long.

3) Put a dab of Krazy Glue on the end of the balsa piece and place it into the notched end of the dowel.

4) Soak the balsa in water briefly, then dip into ink or gouache. A balsa wood nib makes a beautiful, smooth stroke, especially when you dip each edge into a different color.

Cola Pen

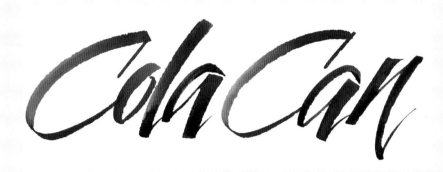

Materials:
- *aluminum can*
- *scissors*
- *masking tape*
- *toothpick*
- *sharpened pencil*

1) *Very carefully* cut a spade shape from the aluminum can and fold in half. It's a good idea to wear protective gloves when you cut the aluminum.

2) Lash the end of the spade shape to the pencil with masking tape and use it on its side to make a cool mark. The side makes your thick strokes, and the tip makes the thin strokes when you tilt it up in your hand.

3) Place a toothpick in the fold of the can, to serve as a reservoir for ink.

4) Add a bit of tape on the bowl of the spade shape to keep the reservoir in place.

Deodorant Container Pen

1) Find an empty deodorant container (you want a wide one), and remove the insides.

2) Fill about halfway with ink.

3) Deconstruct a chalkboard eraser, by taking off the strips. Cram the strips upright into the deodorant container, so they look like french fries. The ink will wick up into the "nib." A super wide tool that's great for signs.

Other Handmade Tools

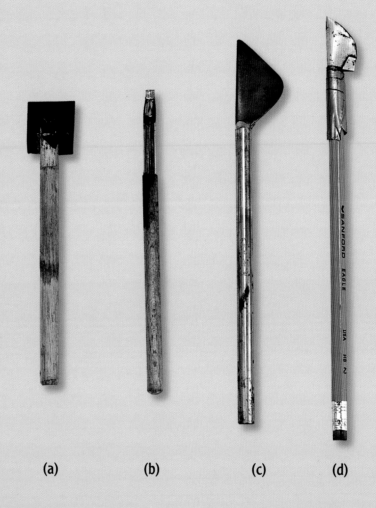

(a) (b) (c) (d)

Roofer's Felt Pen: This is made in the same way as the Balsa wood pen; you can find roofer's felt at home improvement stores. (a)

The Mitchell Witch Pen: This pen creates a unique split in the stroke; it was used to make *Material Spirit*, shown on the next page. (b)

The Butterfly Pen: Invented, created, and lovingly handmade by Chicago's Jim Chin, this pen makes a huge dramatic stroke. Check the Resources section (page 157) for more info on this pen, as well as the moth and dragonfly pens. (c)

Etching Plate Pen: This pen was invented by Peter Thornton, when he discovered that he could make pens using metal etching plates from printers. It is similar in design to the cola pen, but the metal is stiffer and holds up better to pressure than the cola pen. (d)

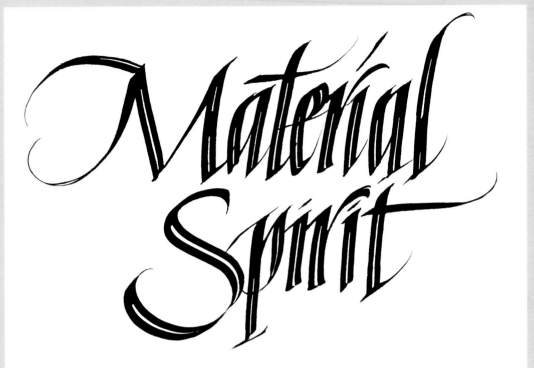

Material Spirit
Artist: Lisa Engelbrecht
Mitchell Witch Pen

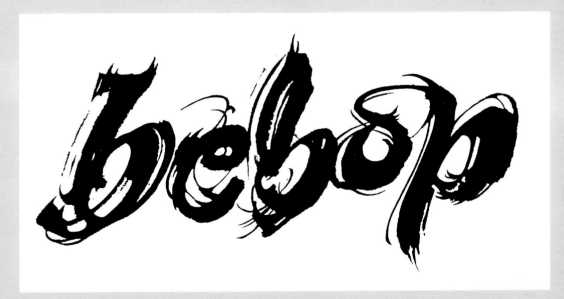

Bebop
Artist: Carl Rohrs
Lettered with a handmade dog's hair brush.

Chapter 10

Flourish

Swirls, Twirls, and Sparkly Things

lourishes are the delicious icing on lettering and are tempting to add to our letterforms. They were originally designed as protection against forgery. In the fourteenth century, special personal flourishes were developed for nobles and businessmen. The personal scribe created a signature flourish that only he could execute and ended each proclamation or missive with this flourish and a wax seal, in case of interception by the bad guys. The Copperplate style of writing developed from these flourishes when it was discovered that the invention of a spinning copper plate with a stylus affixed to one side could achieve these amazing pirouettes on paper.

Today, the flourish can be seen everywhere. Flourish designs are popular with many urban and textile artists, and their popularity has trickled down to the youth culture.

We'll begin with a warm-up of the basic structures that can be created with any monolinear tool (regular pencil or pen), then adding the pointed pen from the Scripty chapter (page 38) or the edged pen from the Old School chapter (page 26). Flourishing is an advanced calligraphic technique, and mastering it requires a lot of practice. Gestural, freeform flourishes can also be used to create elaborate backgrounds. Remember your first painting experience in kindergarten? Put on that big plastic poncho!

Courtesy of the Memphis Calligraphy Guild

Memphis Calligraphy Guild
Artist: Bill Womack

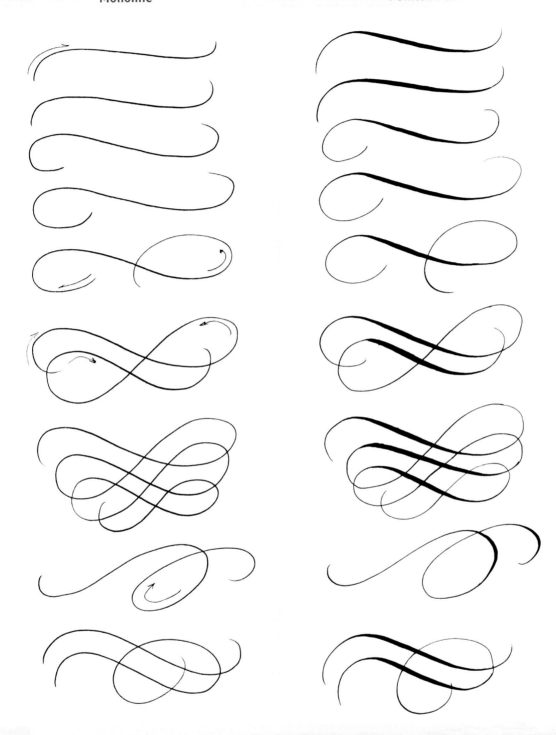

Monolinear and Pointed-pen Flourishes

Practice the movement required for flourishes with a pencil, ballpoint, or gel pen. Notice that the lines from left to right are usually strong, straight strokes and parallel to each other. When practicing with the pencil, add pressure on these strokes—they will become the thick parts, when you make the flourishes with the pointed pen. You will add pressure on the slides and release pressure on the curly side parts.

Flourishing Techniques

The speed of your stroke plays an essential role in dictating the character of your flourish. The basic flourish begins with a slow, steady speed and then accelerates as the hand twists and arabesques off the page. If the flourish is a compound stroke, you will make a lot of speed changes. It's really a disciplined freedom. The dance references—arabesques and pirouettes—indicate the direct parallels between your arm movements and creating flourishes.

Practice with playful abandon. Flourishes need a lot of air, so note the white space as you design the flourish. If you see a flourish with letters, the flourishes should be secondary to the words, adding just a bit of icing—too much and you ruin the cake! The underlying structure of the flourish should be strongly constructed and reflect a parallel scaffolding. Try to keep the curves elliptical and well balanced.

Flourished L
Artist: Lisa Engelbrecht
Pointed brush and colored pencil

Quill Skill, 2004
Artist: Denis Brown
Brause and Mitchell nibs with gouache on paper.

Edged Pen and Compound Flourishes

The pen will not write when you reverse direction, so lift off when making the motion, then go back and fill in upside down. Be sure that you don't cross thick parts of the flourish with another thick part. It makes the flourish look clunky. Note the white spaces you create.

Flourishes **121**

Praise the Lowered
Artist: Damon Robinson
Lovely, graceful flourishes accent the title; they do not overpower it and are well away from the letters themselves.

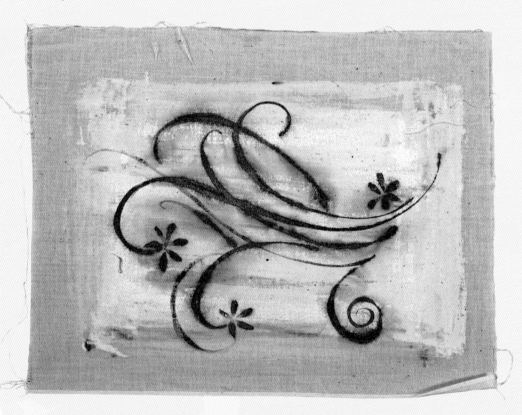

Flourish on Gessoed Canvas
Artist: Lisa Engelbrecht
Jacquard Halo paint and pointed brush. This flourish was sprayed while wet to get the blue bleed.

Flourishes on Fabric

Pointed brush with white acrylic ink on color-washed canvas.

(Below) Freeform flourish on gauze, pointed brush, Pearlescent Liquid Acrylic Ink, and Wite-Out pen on color wash.

Sparkly Things

Adding gold to your letters is so much fun. (Personally, I feel that glam is essential!)

Here are four techniques to instantly glitz up your writing.

Using Gouache with Metallic Powders

Using regular gouaches and floating Schmincke metallic powders gives your letters a beautiful effect. To create these, first mix up the gouache with a couple of drops of water until it's the consistency of old milk—I usually mix up a few colors and dip into them alternately to get a variegated effect. Add metallic powder by shaking a bit over the mixed gouache. Then, dip the pen into the gouache, pick up some metallic powder, and write.

Experiment with other types of powders. Note that some, such as Pearl-Ex, will sink into the gouache.

Dotting glitter glue onto your letters is a super-easy way to get some shine and makes the letters reflect the light.

Metallic Powder

Stickles or glitter glue

Quickie Glue and the Giant Glue Pen

These glue pens go on blue and dry in about a minute. Once they are clear, rub the metallic foil sheets shiny side up onto the dried glue surface, making sure you rub with your fingers into all the nooks and crannies. Aside from traditional, authentic gilding, this is the brightest gold or silver you can achieve, and this is much quicker. For better gold results, use the giant glue pen on a slick surface.

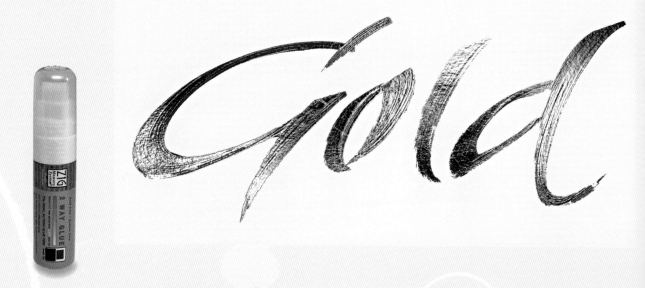

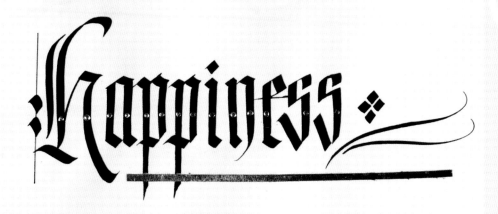

Duo adhesive dots and double-stick tape line with foil.

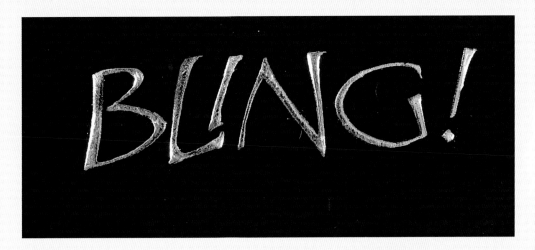

Duo Adhesive

You can use your pen nibs to write with this glue—just be sure to clean them out well after use. You can even put Duo adhesive in a Pilot Parallel pen. This adhesive goes on white and takes longer to dry clear, but it gives a beautiful raised effect. Make sure the adhesive has dried very clear, then apply the foil shiny side up, rubbing well to get in all the corners and crevices.

Apply this Hot Foil Pen Foil shiny side up to dried (and clear) adhesive.

Chapter 11

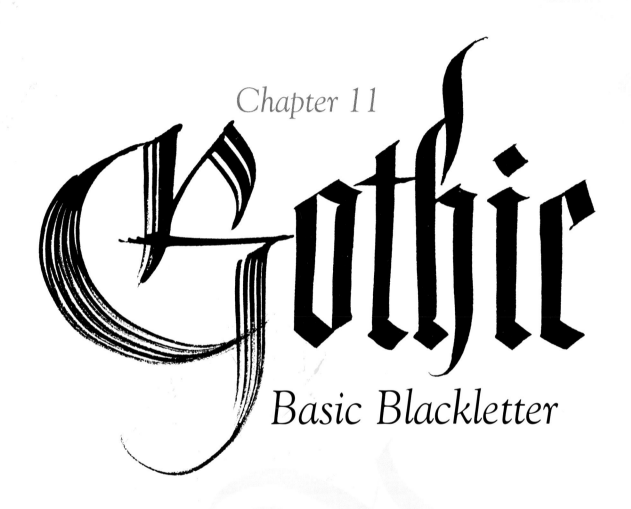

Gothic

Basic Blackletter

Basic Black

Gothic letterforms are easily recognizable. The style is sometimes referred to as Old English, Halloween, or Christmas lettering—although the Old English title is really not accurate. Gothic styles flourished in middle Europe in the twelfth and thirteenth centuries and evolved as a way for the scribe to get a lot of words on the page. As vellum and skins became increasingly harder to supply and the demand for books increased, the letters were compressed. This style is also called Blackletter, because the tight letters and angular style covered the page with so much ink that it actually made the page appear black. Interestingly, the letters reflected the architecture of the day, echoing the pointed Gothic windows of castles. Blackletter can be seen all over Europe. It was also used in Mexico and Central America, a gift from European immigrants. Early graffiti in Los Angeles also reflected this type of lettering. I remember being asked not to teach "that gang writing" in a children's art class. Ironically, it is the lettering style used in hundreds of sacred manuscripts, and Gutenberg based the typeface for his bible on a beautiful version of this script. The beginning letterer will love this style, because it's not difficult to achieve great results.

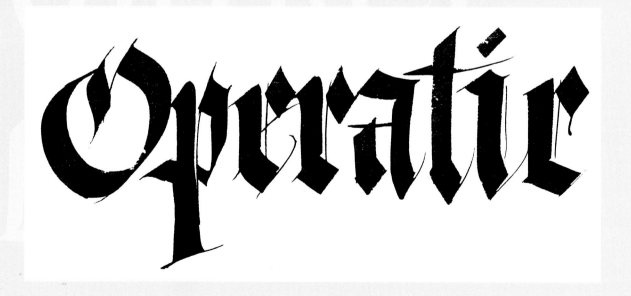

Easy-to-Do Gothic

The underlying rhythm is simply straight strokes at a 45-degree angle, picket fence-style. The space between the letters is exactly the same as the space inside the letters—keep the grid going and you have it! Add a diamond shape at the beginning and end of this stroke, and keep the middle straight and strong. The readability can sometimes be tough with these downstrokes; just be sure to dot your *i*'s! Blackletter master Ward Dunham said it best: If you think about it, the black and white are fighting, and the black is winning. It should be that dense a letterform. Use Gothic letters when you want to convey strength and conviction.

abcdefgh

ijklmnop

qrstuvw

xyz·:!&

Blackletter Minuscules

The exemplar shows a simplified version of the Gothic style. There were as many styles as there were scribes in that day—every small village and town scribe was trying to make a name for him-self by inventing variations of these basic Blackletters. (Hmmm . . . that sounds familiar. See the Street chapter, page 104.)

ABCDE

FGHIJK

LMNOP

QRSTUV

WXYZ

Majuscules

Majuscules varied with each style and scribe. Capitals are interchangeable, and I've given you some basic Blackletter majuscules to work with. Refer to the *Zanerian Manual* (see Resources,

page 157) for other majuscule styles to use with Gothic lettering. I've used regular capital letters with Blackletter, using that grounding rhythm of the picket fence to carry it through.

Rhythmical Creation of Beauty

Maybe it's my German ancestry, but I love Blackletter. I remember an early workshop I took with Lothar Hoffman, another Blackletter master. We were given several styles of letters to try, including Blackletter, Fraktur (in which the stokes are fractured or broken), and Rotunda (in which the strokes are round). I could quickly do these letters pretty well. Am I a reincarnated monk? Was this just my natural style? Who knows? But I felt comfortable and at home with these styles.

You will likely find yourself gravitating toward one writing style—pursue it with all your heart. Of course, I can never write Gothic in a traditional manner—only if I have to! In this sample, *The Rhythmical Creation of Beauty,* I stretched the strokes twice as high as regular-size Blackletter. To play with this style, you can try expanding the basic stroke, slanting your letters, or experimenting with some of the tricks from the Tricky & Functional chapter (page 80).

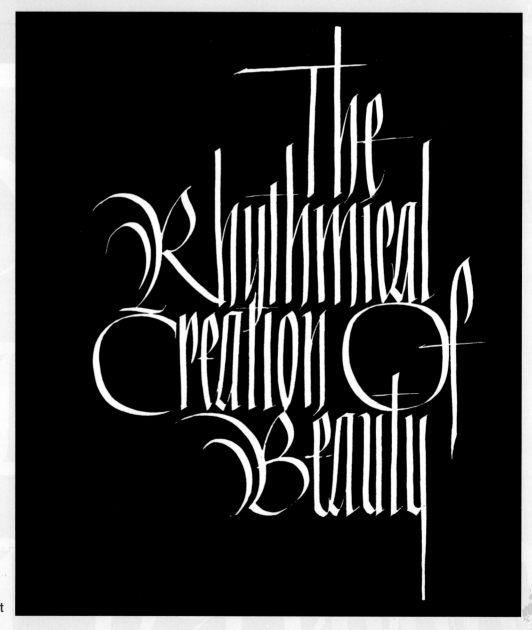

**The Rhythmical
Creation of Beauty
Artist: Lisa Engelbrecht**

Six monarch butterfly cocoons clinging to the back of your finger hung suspended their folden wings trembling ... Art is through the throat

Strength

Wicked

Wicked
Aritst: Stephen Rapp
To get that old, eaten-away look, Stephen used a fine brush and white paint to occasionally randomly break into the letters after writing in the original Blackletter style

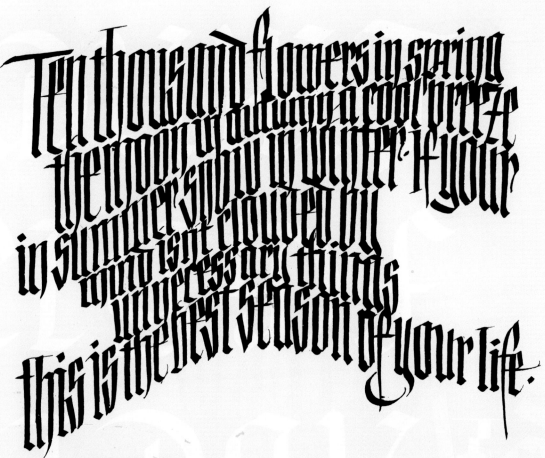

Ten Thousand Flowers
Artist: Lisa Engelbrecht

Glen Epstein gives us some the finest examples of expressive Blacklettering. Here are a few samples of his wonderful work, below and on the following two pages. (Notice the rhythm!) You can feel the life in his letterforms. His marks are truly heartfelt and express the text in a unique way.

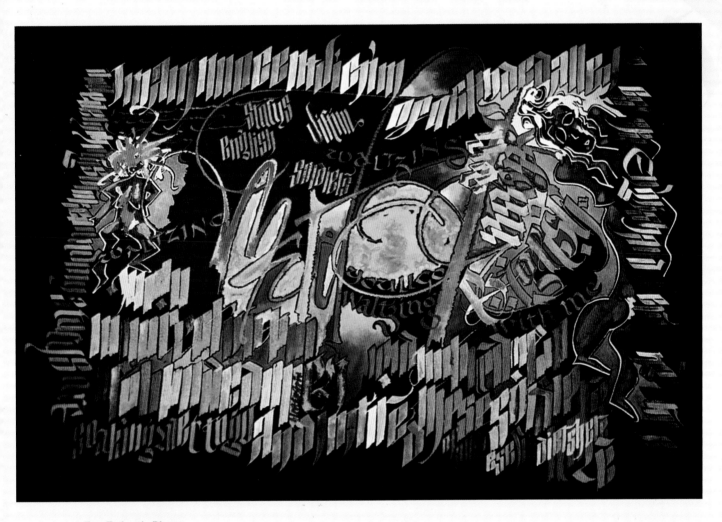

Tom Trabert's Blues
Artist: Glen Epstein

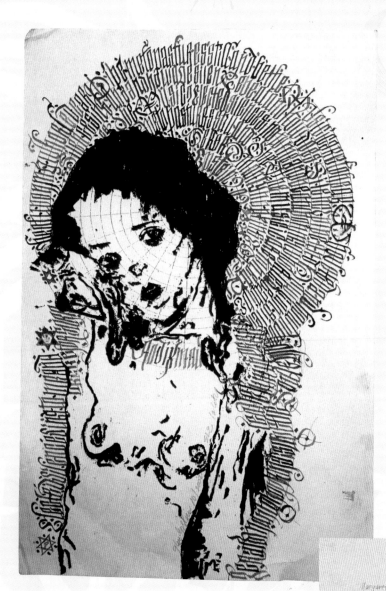

Einsatzgruppen16—Girl with Halo
Artist: Glen Epstein

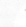

Artist: Glen Epstein

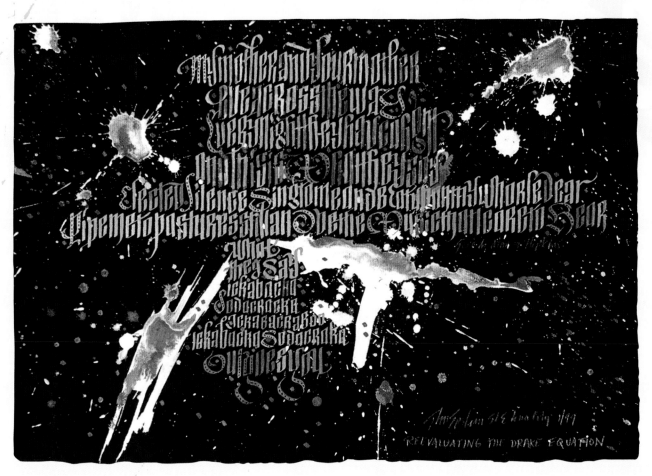

Reevaluating the Drake Equation
Artist: Glen Epstein

Mixed Media

and Letterforms

Design Technique Explorations

Mixed media and collage are exciting and accessible forms of expression, whose discovery has given birth to an exciting new craft movement in this country and beyond. I discovered collage when I misspelled a word on a fabric piece I was working on. I layered a piece of fabric over the typo and lettered it again, leaving the frayed edges and topstitching. No one was the wiser, and I loved the freedom the process gave me to work with multiple layers. It is difficult to make mistakes that cannot be corrected in collage.

On my AIDS project quilt piece, I transferred my friend Ed's picture onto fabric and sewed the piece onto the quilt. But, this was only the beginning. I then added memorabilia, rings, band medals, and hand-crocheted doilies made by my grandma. The art came alive for me. I was celebrating these mementos of my relatives and friends by enshrining them in my art instead of leaving them to languish in a forgotten box. There is a long history of people using fabric to express family history and culture, through quilts, hangings, and pictures.

Remember to choose themes for your projects that are meaningful to you, and skip projects that you don't find interesting or exciting. Authentic themes and exercises in self-exploration make the best art.

Bertholt & Ute
Artist: Lisa Engelbrecht
Mixed media on unprimed canvas
I found this picture at a swap meet. It was dated June 15, 1939, Germany, and it fascinated me. I wondered about this couple and what the future held for them. Perhaps the man died in the war. Before I began lettering, I washed my fabric with acrylic inks and walnut inks. I wrote, "Love is stronger than death" in Blackletter, using a couple of colors of FW inks. I added bits and pieces of related stuff, trying to pick up the colors of the wash and the photo. Was her dress burgundy?

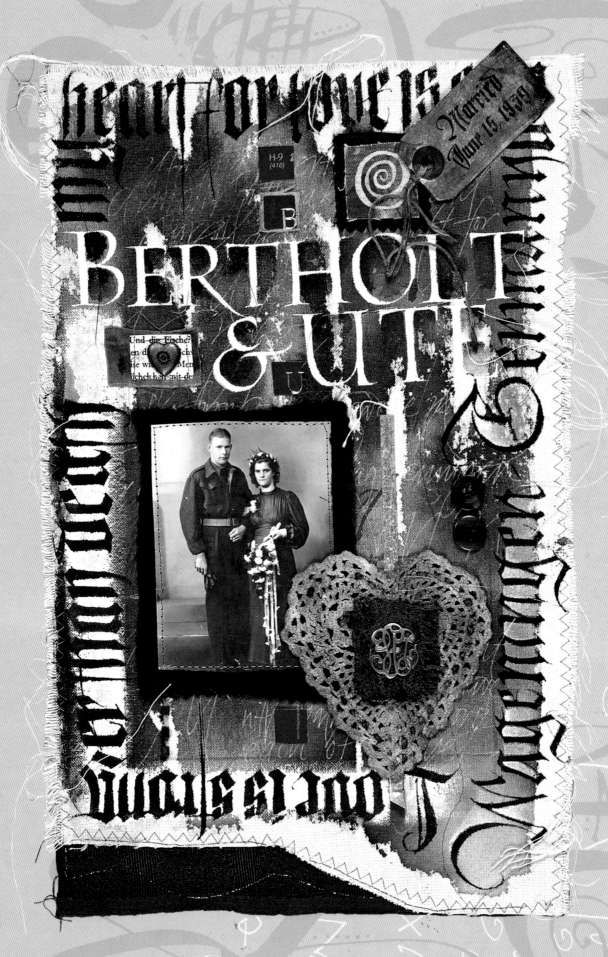

Design

Design of the page is important when you are playing with different elements. Begin with a focal point—the eye catcher. This element should shout at you. The next piece of the art will speak to you. And the third will whisper. Think Shout/Speak/Whisper. It is a great way to start a well-designed piece. Think also in terms of threes, and avoid overembellishing a piece by filling every open space with buttons and charms. Think about what you want to convey. This is where your words come in, the beautiful letters providing visual eloquence.

Creating a Well-Designed Mixed-Media Piece

1) Collage is visual storytelling. Begin with your idea. What colors and textures come to mind when you remember this person, day, or event? Using these colors, make a wash of color using diluted acrylic inks on heavy paper or fabric. Leave areas of white for sparkle. The edges of your wash can be free form, or you can make the wash square or rectangular in shape.

2) Choose a photo or word to anchor the piece with its big idea (the Shout). Photos can be transferred to fabric using T-shirt transfer paper, available at any office store. Your large meaningful word can be sketched first with the purple disappearing-ink pen. I like to layer various colors and textures of paper and fabric behind my photos and big words.

3) The next element should be smaller. Don't paste or sew anything to the background yet; keep it fluid for now.

4) Now add the tiny, whispery elements. These can be words scribbled in the background—no one needs to even know what they are. In fact, stream-of-consciousness writing is fine. Art should be cathartic; get it all down in your work!

5) Play with placement. Be aware of the negative spaces you create; you should have the same amount of positive space. The white spaces that surround your work should be pleasing, as well.

6) When you are ready to join the elements, you can stitch them to the color-washed base paper or fabric by hand or machine, or you can use a credit card to swipe the fabric, image, or paper elements with a thin layer of Yes glue or gel medium and glue them onto the base fabric. Small charms, coins, and the like can be adhered with Aleene's Jewel-It Glue. This adhesive works well for no-sew beading!

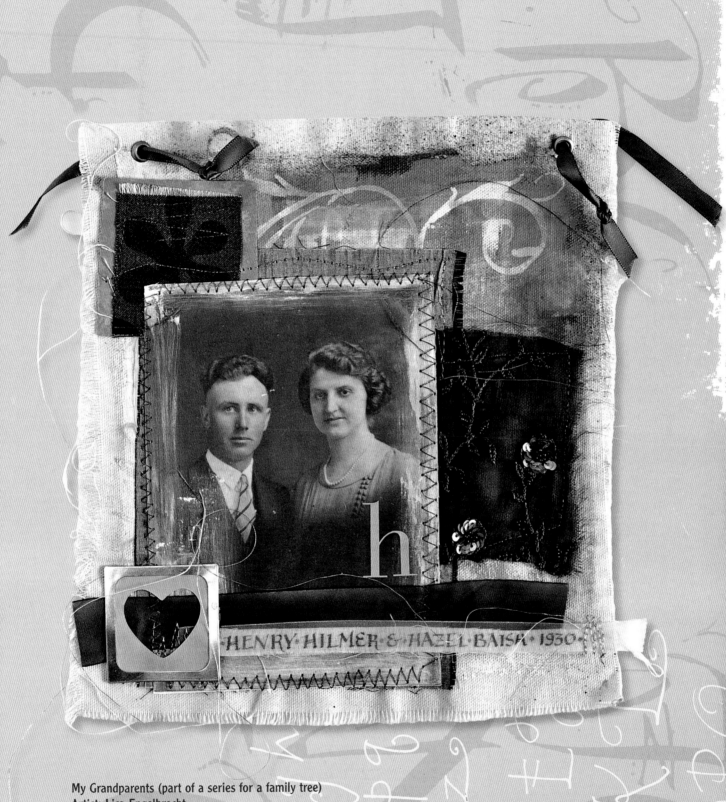

My Grandparents (part of a series for a family tree)
Artist: Lisa Engelbrecht
Acrylic inks, photo transfer, and mixed media on canvas

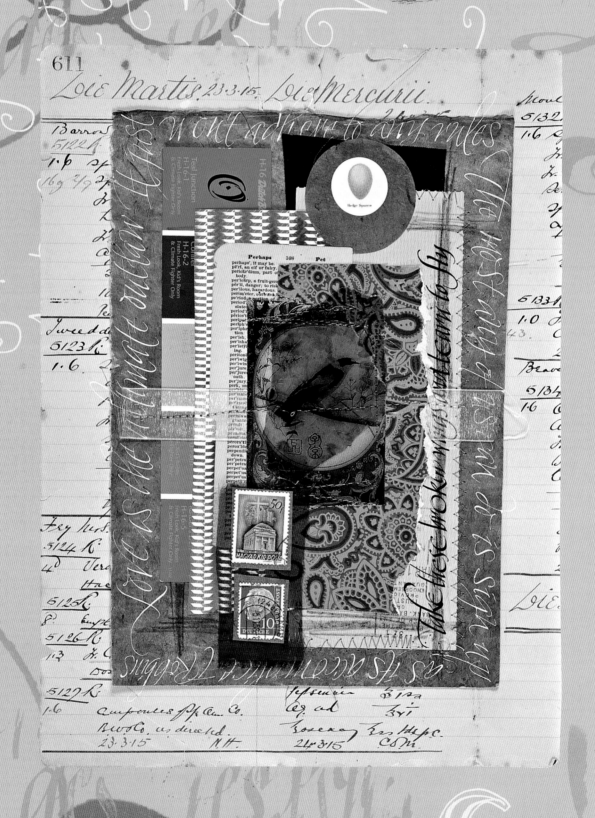

Love Is an Outlaw
Artist: Lisa Engelbrecht
Vintage ledger paper and mixed media

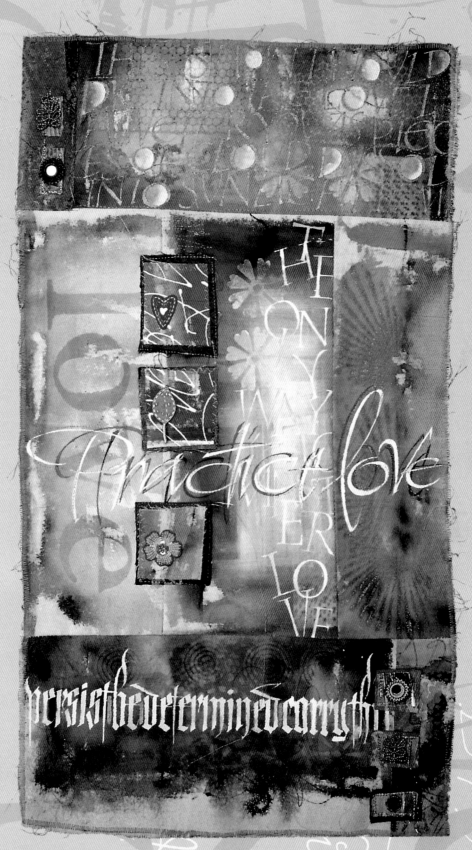

Practice Love
A quilt comprising various surface techniques was sewn together, hand lettered, and then topstitched.

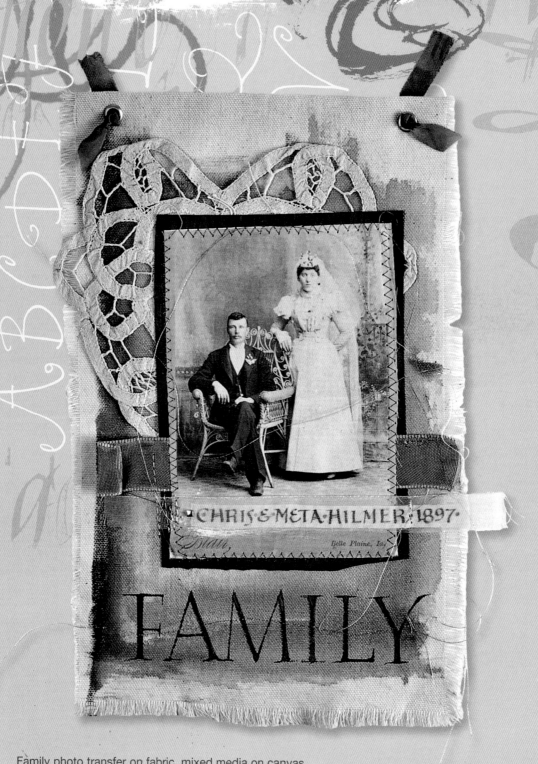

Family photo transfer on fabric, mixed media on canvas

These two pieces are part of a larger family tree made on fabric. To transfer the pictures to fabric, the original pictures were printed onto transfer paper* (this brand was June Tailor). The transfer paper acts like a decal. It was ironed onto smooth muslin, pressed for about fifteen seconds, then the paper was removed, leaving the transferred image. The photo transfers on muslin were machine stitched onto heavier canvas. The transfer is transparent and will pick up any color underneath. (Transferring images to a rough canvas will result in a distressed, blurry look.)

*Transfer paper is available for the color photocopier or the inkjet printer. If you choose a photocopy transfer paper, be sure you reverse the images on the copier before printing. This holds true for the inkjet-printer transfer paper, as well. To transfer your images using inkjet transfer paper, you'll first need to scan your artwork or photos into your computer.

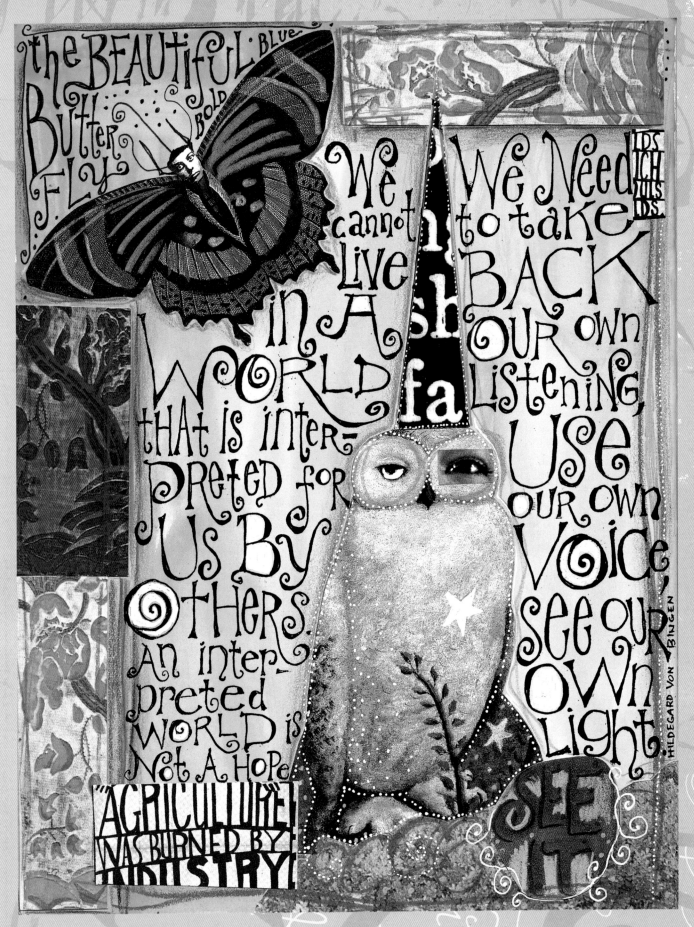

the BEAUTIFUL BLUE Butter FLY BOLD

We cannot Live in A WORLD tHAt is inter-preted for us By Others. An inter-preted WORLD is Not A Hope

"AGRICULTURE WAS BURNED BY INDUSTRY"

We Need to take BACK OUR own Listening, USE OUR OWN VOICE, SEE OUR OWN Light.

SEE IT

HILDEGARD VON BINGEN

See Our Own Light
Artist: Teesha Moore
Beautiful lettering, thoughtful collage, and great design combine to create an intriguing piece.

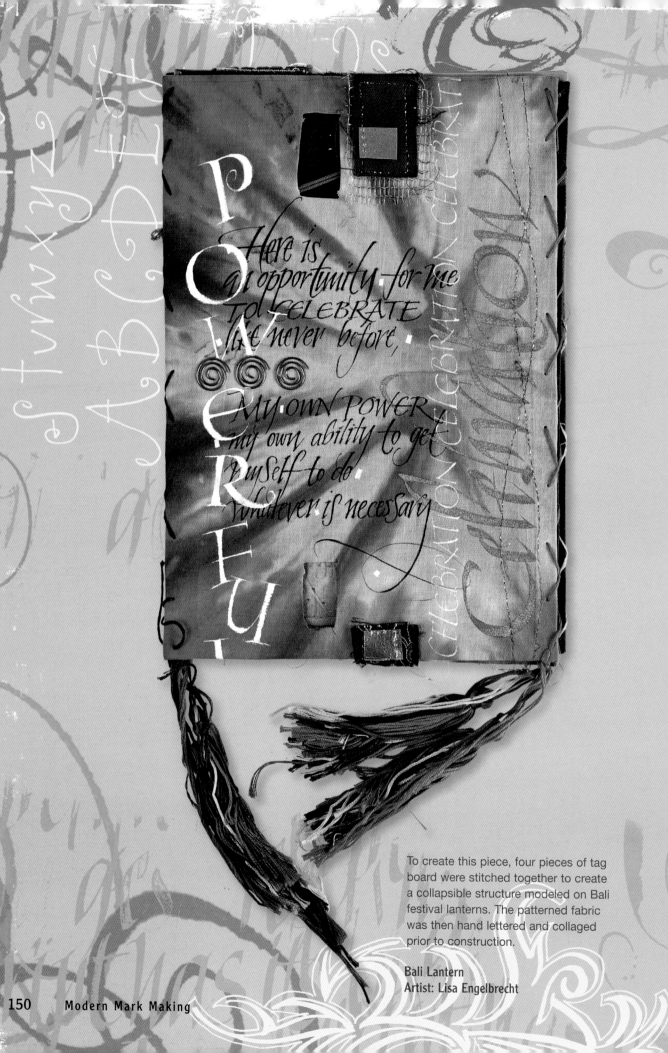

POWERFUL

Here is an opportunity for me to CELEBRATE like never before, My own POWER, my own ability to get myself to do whatever is necessary

To create this piece, four pieces of tag board were stitched together to create a collapsible structure modeled on Bali festival lanterns. The patterned fabric was then hand lettered and collaged prior to construction.

Bali Lantern
Artist: Lisa Engelbrecht

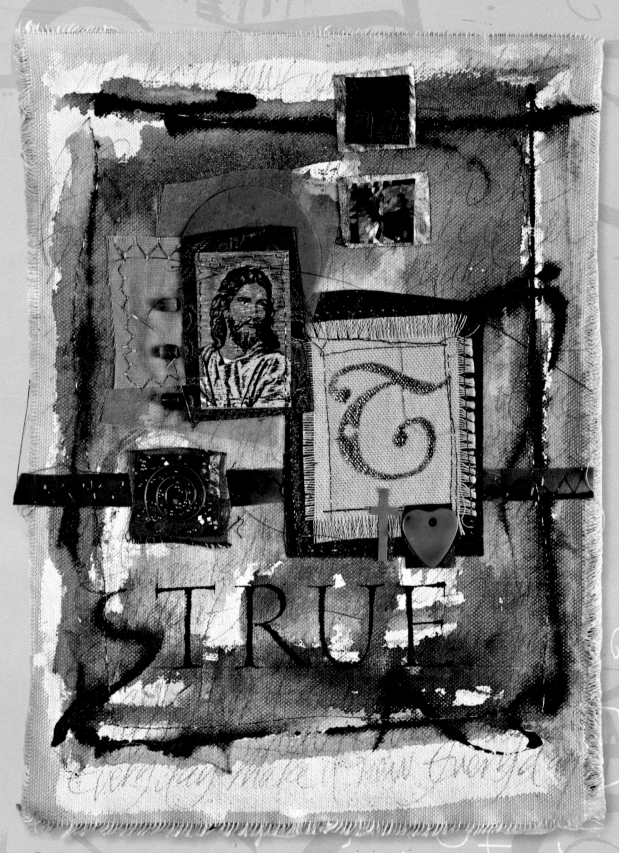

True
Artist: Lisa Engelbrecht
Mixed media and acrylic inks on unprimed canvas

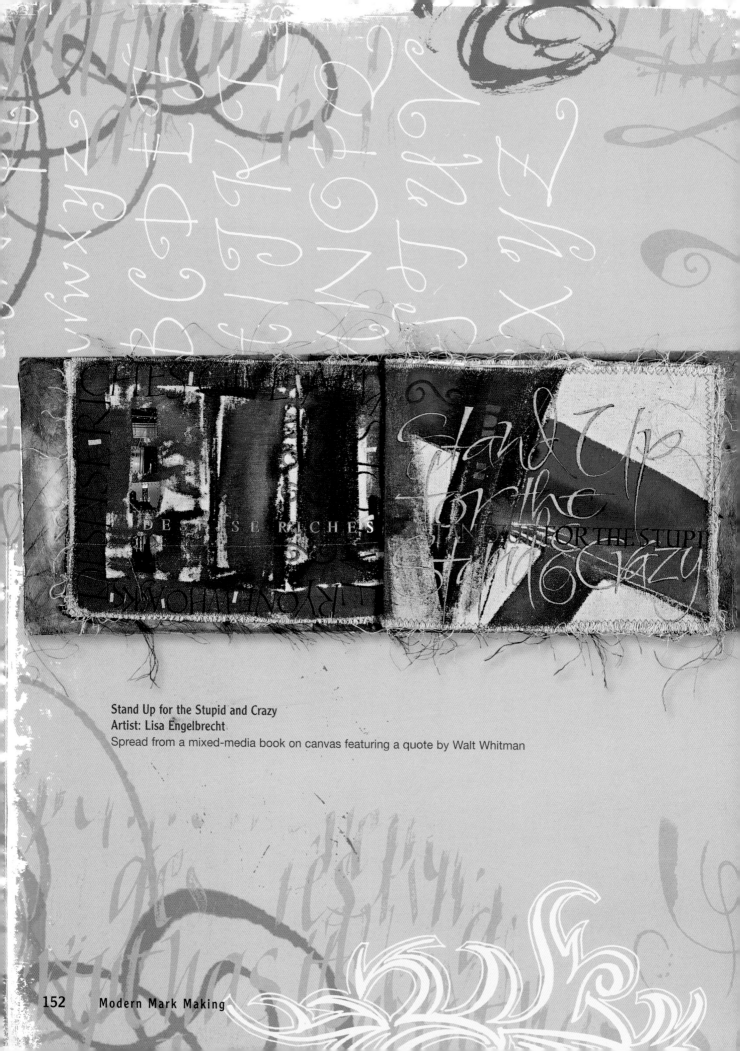

Stand Up for the Stupid and Crazy
Artist: Lisa Engelbrecht
Spread from a mixed-media book on canvas featuring a quote by Walt Whitman

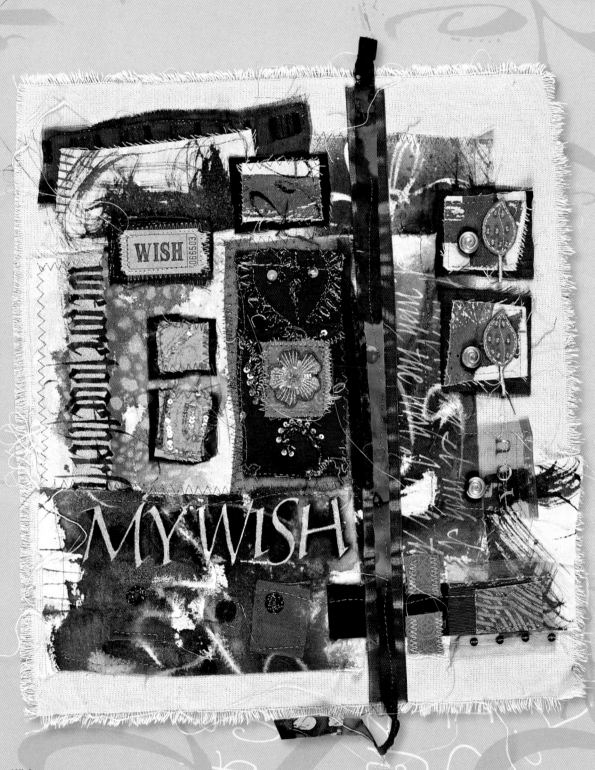

Wish
Artist: Lisa Engelbrecht
Acrylic inks, fabric collage, stitchery, and mixed media on unprimed canvas

The Artists

Traci Bautista

Venice Beach, California, USA
www.treicdesigns.com
traci@treicdesigns.com
http://kollaj.typepad.com

Traci Bautista is a mixed-media artist, author, teacher, and creative director of treiC Designs. She creates vibrantly colored artist books and mixed-media paintings layered with rich textures, "girlie glam" ink drawings, and freestyle lettering. She also designs a line of clothing called REVAMPED. Her artwork has been featured in various magazines, books and on the HGTV and DIY networks. Traci is the author of *Collage Unleashed* and writes a column called "Creativity Unleashed" in *Somerset Studio* magazine.

Jill Bell

Missouri, USA
www.jillbell.com
jill@jillbell.com

Jill Bell creates original custom-lettering solutions of any nature (logos, titles, fonts, taglines, handwriting) for all of the usual suspects: advertising, entertainment, packaging, editorial, corporate, publishing, and government, as well as for other designers and most of the major type companies. She graduated from UCLA and Otis/Parsons and worked for well-known graphic artist Saul Bass as a sign painter. She has spoken at type conferences and judged type design contests. Her work has appeared in books and magazines, and she enjoys finding her fonts in both the obvious and oddest places. She loves cats, fine dining and wine, music and movies, and reading and walking.

Denis Brown

Dublin, Ireland
denis@quillskill.com

Barbara Close

La Mirada, California, USA
www.bcdezign.com

Barbara Close is a lettering artist living in southern

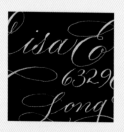

California. She teaches workshops around the country, in Canada, and locally. Her studio class in Santa Ana, California, is a year-long study of calligraphy with a certificate on completion. Her work can be seen in Marcel Schurman greeting cards and *Somerset Studio* magazine.

Glen Epstein

Iowa City, Iowa, USA
www.glenepstein.com
glenepstein@mchsi.com

Glen Epstein's daughter, Sara, gave him a second granddaughter in the spring of 2006, which also marked his twenty-fifth and final year of teaching calligraphy at the University of Iowa. Glen is a charter founding member of the UI Center for the Book.

Linda Hirsh

Norco, California, USA
inkinofu@sbcglobal.net

Linda Hirsh's passion is any kind of pointed pen. She enjoys teaching pointed pen and One Stroke Painting and also combines the two

Teesha Moore

Renton, Washington, USA

www.teeshamoore.com

artgirl777@aol.com

Teesha Moore is the organizer of Artfest, a popular art retreat, and also edits and publishes an art magazine called *Art & Life*. She sells her collage sheets, rubber stamps, and prints through her website and teaches when she can squeeze it in.

Deborah G. Powell

Orange, California, USA

dgp2ink@yahoo.com

Deborah Powell is a lover of letters, words, and textures and is a freelance calligrapher.

Stephen Rapp

Lakewood, Ohio, USA

stephen.rapp@att.net

Stephen Rapp began studying calligraphy in 1989. His work has since graced a wide range of projects, from CD covers to recreations of spy documents for the Washington Spy Museum. Since 2000, he has been a member of the Lettering Design team at American Greetings. In addition to hand-lettering, Stephen is also actively involved in font design. He has recently designed new fonts for P22/Veer.

Damon Robinson

Los Angeles, California, USA

www.praisethelowered.com

damon@praisethelowered.com

Damon Robinson's art is born out of his Mexangeles-influenced graphic design practice. Wrestling masks, low riders, lucha girls, and other favorite images are combined with familiar urban motifs and assembled into impressive, large-scale artworks and sculpture. He is also the creative force behind Praise the Lowered and Black Van Industries. He lives in Los Angeles with his beautiful wife and daughter.

Carl Rohrs

Santa Cruz, California, USA

rohrs@baymoon.com

Peter Thornton

Cleveland, Tennessee, USA

petert1811@aol.com

Peter has been an enthusiastic calligrapher and teacher for more than thirty years. He now works from his new studio (with his new and beautiful wife, Sherri) doing workshops and running a mini correspondence course. He is also very happy.

Bill Womack

Bill Womack was a noted and respected letter artist, who used calligraphy and graphic design. He worked as the head of the Memphis College of Art until his death in 2003. *His work is reproduced with the kind permission of the Memphis Calligraphy Guild.*

Xandra Zamora

www.xyzink.com

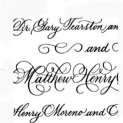

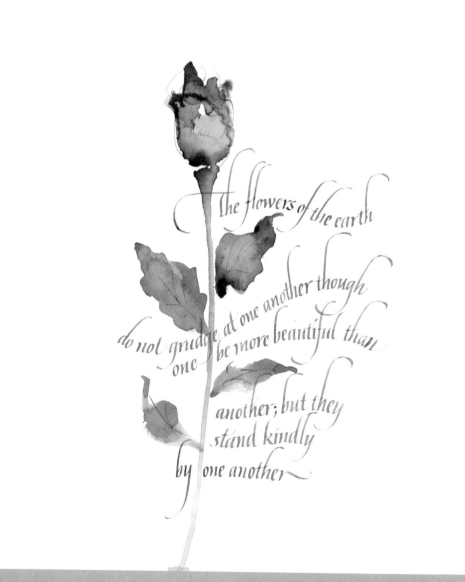

The Flowers of the Earth
Artist: Lisa Engelbrecht
Watercolor

About the Author

Lisa Engelbrecht is a lettering and multi-media artist and calligraphy instructor and has taught for years at Cerritos College in California. Lisa teaches internationally, specializing in workshops and classes on lettering on fabric, experimental lettering, and the creative process. Lisa has been on the faculty of six international lettering conferences and teaches at collage, quilting, and alternative arts conferences nationwide. In 2006, Lisa introduced new multi-media classes at the International Quilt Show in Houston, Texas. She is interested not only in classical letterforms but also alternative surfaces for lettering and in current street influences on modern calligraphy.

Lisa's work is featured in *Artist's Journals and Sketchbooks* and *Beyond Paper Dolls*, by Lynne Perella, *Quilted Memories*, by Lesley Riley, *Altered Couture*, *Letter Arts Review Annual*, and *Mary Engelbreit's Home Companion*. She is a frequent contributor to *Somerset Studio* magazine, and her work on fabric has been featured on the covers of *Legacy* and *Quilting Arts* magazines. Lisa is also a freelance lettering artist for American Greetings. Her classes are fast, fun, and totally stress free!

You can contact Lisa at lengelbrecht@earthlink.net. Please visit her website: www.lisaengelbrecht.com

Acknowledgments

I have to begin with thanking Mrs. Rudholm, my 7th grade art teacher, whose classroom I couldn't wait to be in—a class that somehow made middle school bearable.

I have Marsha and Larry Brady to thank for so many things: my attention to detail, my formal Romans, and for being the consummate teachers—something that I can only aspire to. Thank you for allowing me the amazing opportunity to teach in your program, and for entrusting it to me. It was my honor to study with you both.

To my friends, the artists who did not hesitate to contribute their beautiful work to this book when I asked. You've made this book 'legit' with your talent and I'm so proud to know you!

To my students, who've always taught me more than I taught them. Thank you for your enthusiasm and spirit.

Special thanks to Traci Bautista, who unrelentingly encouraged me to write this book. (It's really done!)

To my special friends and colleagues who helped me daily with their encouragement—I hope you know how much this means to me.

To my editor, Mary Ann Hall, for her gentle guidance through this process with patience, vision for what this book could be, and support for this first time author!

My designer, Dawn Sokol, who willingly took my myriad of ideas (and tearsheets!) and pulled it all together into this beautiful book. Thank you, too, for your patience with me.

Very importantly, I thank my mom who guides me from above in all things, and who always did things her way with style and flair.

And finally to my kids, Kristin and Jeff, for allowing their childhoods to be interrupted by studio time, my classes, and weekends away. I know I never fit the description of a normal mom, and I appreciate that you were OK with that. I love you both.